# DARKROOM2

COPYRIGHT © 1978 BY LUSTRUM PRESS INC.
BOX 450 CANAL STREET STATION, NEW YORK, NY 10013
JOHN FLATTAU, RALPH GIBSON AND ARNE LEWIS
ALL RIGHTS RESERVED UNDER
INTERNATIONAL AND PAN-AMERICAN CONVENTIONS
DESIGNED BY ARNE LEWIS
TYPOGRAPHY BY HAROLD BLACK INC.
PAPER SUPPLIED BY GOULD PAPER CORPORATION
PRINTED BY RAPOPORT PRINTING CORPORATION
BOUND BY SENDOR BINDERY INC.
LIBRARY OF CONGRESS CATALOGUE CARD NUMBER: 78-69948
ISBN: HARDCOVER 0-912810-22-X, PAPER 0-912810-21-1
PRINTED IN THE UNITED STATES OF AMERICA

AN OUNCE TO A POUND TO A GALLON

EDITED BY JAIN KELLY
LUSTRUM PRESS

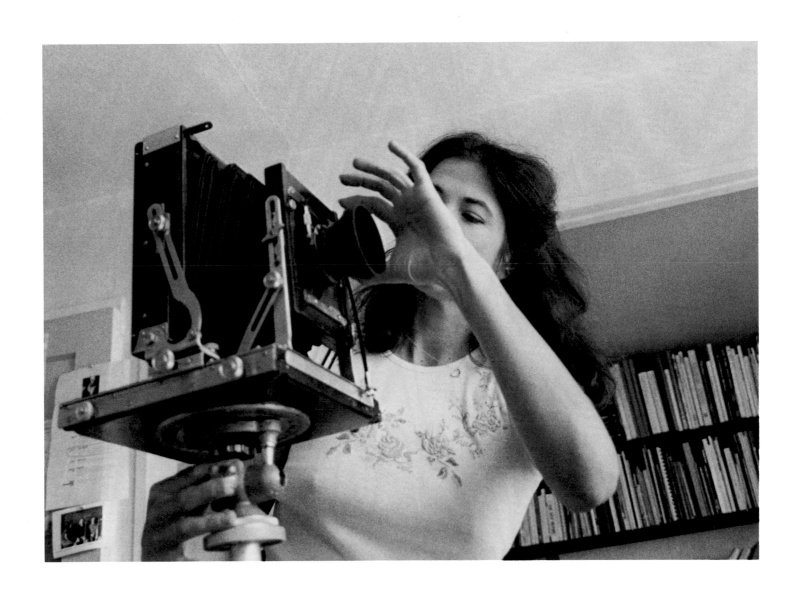

## JUDY DATER

Judy Dater was born in 1941 in Hollywood, California. She studied art for three years at UCLA. After transferring to San Francisco State University, she majored in photography and received her BA and MA degrees in art.

In 1976, Dater received a National Endowment for the Arts grant, and in 1978, a Guggenheim. The Oakland Museum gave her the Dorothea Lange award in 1974.

Dater, who teaches at the San Francisco Art Institute, has been published in numerous magazines and books. The book WOMEN AND OTHER VISIONS (Morgan and Morgan, Dobbs Ferry, N.Y.), done in collaboration with Jack Welpott, was published in 1974. Currently she is working on a book about Imogen Cunningham, to be published by New York Graphic Society, Boston, Mass.

Selected one-woman shows:
1965: Aardvark Gallery, San Francisco, Calif.
1972: School of the Chicago Art Institute, Chicago, Ill.
    Witkin Gallery, New York, N.Y.
1973: Center for Photographic Studies, Louisville, Ky.
1974: University of Colorado, Boulder, Colo.
1975: Oakland Museum, Oakland, Calif.
    Silver Image Gallery, Tacoma, Wash.
1976: Spectrum Gallery, Tucson, Ariz.
1977: Nova Gallery, Vancouver, British Columbia, Canada
    Susan Spiritus Gallery, Newport Beach, Calif.

Selected collections:
University of Arizona, Tucson, Ariz.
International Museum of Photography at George Eastman House, Rochester, N.Y.
Museum of Modern Art, New York, N.Y.
San Francisco Museum of Art, San Francisco, Calif.
Pasadena Museum of Art, Pasadena, Calif.
National Gallery of Canada, Ottawa, Ontario, Canada
Bibliothèque Nationale, Paris, France
Metropolitan Museum of Art, New York, N.Y.
Chase Manhattan Bank, New York, N.Y.
University of Kansas Art Museum, Lawrence, Kans.

My work is rooted in 19th-century portraiture. I like very formal pictures, elegant and classical. I feel that by using a 4 x 5 view camera with natural light, I get a similar feeling. However, I would say that my portraits are more straightforward, without the romanticism of the past.

I began with self-portraits, but they were unsatisfactory because I could not see what I was doing. So I started to use other women as stand-ins. I had done nude studies of myself and so I began to do nudes of them.

I realized that I wanted to include the face in the study, to make a "nude portrait." Not too many photographers had done this previously; nudes used to be anonymous. I felt that if the face were included, another type of impact could be achieved because stripping away clothing makes people defenseless. A psychological event takes place because the subject knows he or she is recognizable.

Another approach to the "nude portrait" is to photograph only the face of the unclothed subject. Even though the body does not appear in the photograph, something unusual is happening. Sometimes it is possible to tell by the subject's face that he is in the nude; sometimes it's not.

Usually my subjects are very curious to see what they look like in the picture, and they seem to enjoy the experience of being photographed. They are almost never professional models, and are not used to seeing photographs of themselves in the nude. I never push anyone into posing. I ask only once, and if the person seems very comfortable with the idea, I go ahead.

Sometimes I strive for an erotic feeling in the picture, but it is not essential. It depends on the type of give and take between the photographer and the model, and whether or not the person's nature is sensual.

Traditionally, most photographs of nudes have been done of women by men. Much of this work is beautiful, but now women are beginning to do nude studies of men. Women artists have much less to fall back on, and this lack of stereotypes is a challenge. One hopes it will force women to make new discoveries about how to photograph men. What I did initially in my work was simply to copy what had been done with female nudes, but that approach didn't feel right.

I find that the men I photograph seem to represent a cross section of lifestyles, economic backgrounds and age groupings. As in my portraits of women, I attempt to portray the men honestly, letting the blemishes show. I take a tough look at people, but I do not treat them cruelly.

I do not place my subjects in a studio setting. I want a more natural environment, preferably the person's own home. To set up for a portrait session, I find or arrange a simple backdrop, such as a doorway or a drape.

This morning I plan to photograph a male nude. To make a backdrop, I drape a white sheet against a window

to diffuse the bright sunlight (Figure 1), and then I pose the subject on the window sill.

**Figure 1.**

**Figure 2.**

I use a Soligor Spot Meter to determine my light reading. I prefer a spot meter because it has a narrow angle of acceptance of light; I can be sure my exposure calculation is not thrown off by extraneous light.

My tendency as a photographer is to expose for the shadows and to develop for the highlights. As I am metering the subject, I think in terms of the Zone System, which is numbered on a scale of Zero (maximum black) to Nine (threshold gray into pure white of the paper). I meter the darkest area in which I want detail, the subject's chest,

which falls in Zone Four (dark gray) (Figure 2). Now I meter the highlights on the sheet, which fall slightly above Zone Nine (Figure 3). There is approximately a 5½-zone difference between the high and low readings; the "normal" (N) difference would be considered 4 zones. I know automatically that I will have to underdevelop the negatives to reduce the contrast. My exposure, f/32 at 1/25th of a second, places the negatives in Zone Four.

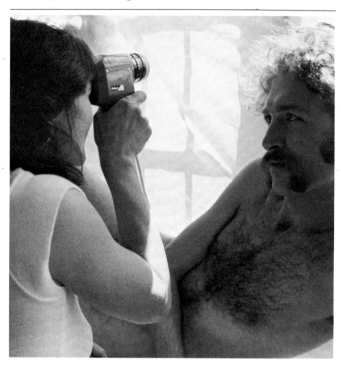

**Figure 3.**

I will use the same exposure for all the photographs I make this morning. Sometimes I make a second exposure of a particular pose, but as a rule I make a decision and assume it will turn out for the best.

Usually I prefer Plus-X or Ektapan films, both of which are relatively slow. Slow films work best in a situation in which I want to increase contrast through overdevelopment. For this session, I am using Tri-X because a faster film works best with a very bright, high contrast lighting situation. Tri-X gives a "soft" negative and it underdevelops better than a slow film. I avoid using Tri-X in situations in which I must overdevelop, because overdeveloping causes fast films to build up density on the entire negative; with slow films, overdeveloping builds density only in the highlights.

I rate Tri-X at 200 ASA, which seems to give the best negative for my lens, meter and camera system. I clean the area where I'm going to load and unload my film, to eliminate dust (Figure 4).

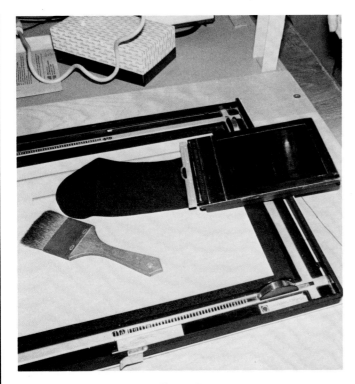

**Figure 4.**

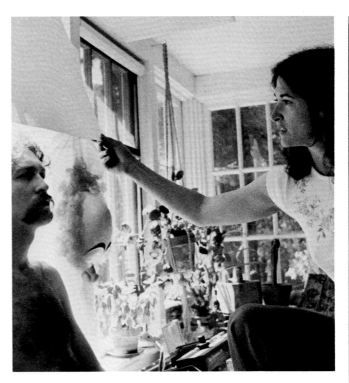

**Figure 5.**

I prefer sheet film, but I don't have any loaded today, so I am using film pack. The advantage of film pack is that it's much easier to handle when I'm traveling because I don't have to worry about using a changing bag in dusty hotel rooms. The disadvantage is the ease with which it can get scratched, because it is much thinner and more delicate than regular sheet film.

To photograph the model I decide to use a 135mm lens with my 4 x 5 Deardorff. Most of my portraits are done with the 135mm, although occasionally I use a 90 or 210mm. For many years, I also used a 150mm a great deal. The 135mm is my favorite because it places me at just the right distance: 6 to 8 feet. With a longer lens, the subject is too far away; with a wider lens, I get distortion.

The 4 x 5 Deardorff and the 135mm lens contribute to my feeling of being in control of the portrait session. With a 35mm camera, the subject expects everything to go quickly. People respond differently to a 4 x 5; the session is more of an event, and they are prepared to spend the time necessary for me to pick up their feelings, to make suggestions and to direct their actions.

As the model and I are working together, I study the lighting on his face and body. I decide it would be a good idea to have more light reflected on his face. I experiment with holding up a white card, which fills in the shadows and adds a luminous quality to the skin (Figure 5). I am pleased with and excited about the aura of the face.

I study the subject's movements, getting a feeling for how he expresses himself physically: how he sits, how he reclines, how he holds his head and makes gestures with his hands. Hand movements are especially important to me as a means of revealing personality.

I consider whether or not to use props in this portrait. Generally I prefer that props belong to the model, so that they are extensions of personality. Many props have appeared in my photographs, from a hair barrette (Figure 9) to cooking utensils (Figure10).Props, like the interior of the subject's home, provide clues to the subject's personality.

To make a portrait of this subject, I decide to do something slightly different. I place two masks by his face. They are two aspects of the model, symbolic references. Symbolism should not be too obvious. Generally I try to convey symbolism through a subtle use of light and gesture.

After we work with a few different poses, I see that he is sitting in a position I like, with his eyes closed. I decide to go closer, and to try a slightly different angle. Usually my approach is to find a pose that pleases me, and then to work with it until I'm tired of it.

The first several photographs of the morning were what I would consider nude studies. A nude study is more detached; it makes the person into more of an object. Step by step, something else has been evolving. Now the photograph is turning into a "nude portrait," an attempt to convey personality. Perhaps I'll try a long shot and then a

close-up. I start to go closer with the camera, and I begin to lose the body in the ground glass.

An hour has passed, and I have made eight exposures. Typically, a portrait session might require one and a half to two hours to make about two dozen photographs.

I develop my negatives in Kodak HC-110, which I've been using for less than a year. Previously, I had developed with Rodinal, but I tended to get thin, flat negatives. HC-110 has given me a much fuller negative.

Ordinarily I use 1 part stock solution HC-110 to 7 parts water. Because film pack tends to be more contrasty than sheet film, I dilute HC-110 1:15 for this set of negatives.

Normally, my development time for the Tri-X film pack at 200 ASA is 10 minutes with HC-110 at 1:15. However, because there is a 5½-zone difference between the high and low light readings, I underdevelop to reduce contrast. I decide on a development time of 6½ minutes.

I like to presoak my film for 1 minute, which affects the developing time. The advantage of presoaking is that it facilitates more even developing. Presoaking primes the film to receive the developer, but it takes longer for the chemicals to get to the film. For this reason, 30 seconds additional developing time is recommended, which means I will develop for 7 minutes.

When I develop sheet film, I place the film in hangers which go into tanks. Film pack is too flimsy to stay in holders; it must be developed in trays. I must be careful because this kind of film tends to scratch more easily, which is a disadvantage when I have to tray-develop.

I set the timer at 8 minutes, which allows 1 minute extra for the presoak. Then I turn out the lights, unload the film, and develop. I agitate the tray continuously.

I use a water stop bath for 20 seconds, because acetic acid is rough on the film, and can cause pinholes. Then I use regular Kodak fixer for 10 minutes.

I have developed two pieces of film from the session, to see how they come out. As I examine them, I check on details in the shadows (Figure 6). I check the highlights, to see if I think they are going to be too "hot." The detail and tonalities of this particular negative are perfect. If I think the highlights will be too "hot," I compensate in the next batch by underdeveloping a little more.

I wash film pack in a Polaroid bucket rather than a tray (Figure 7). A Polaroid bucket is normally used to give Positive/Negative materials a sodium sulfite bath. However, I have discovered that 4 x 5 film pack, which is slightly larger than cut sheets, fits into the slots of the bucket perfectly. Then I simply insert a water nozzle.

I wash the film pack for 1 minute. Then I use hypo eliminator for 1 minute, and wash another minute. I add an eye dropper of Photo-Flo to the bucket for 30 seconds, and I hang up the film to dry.

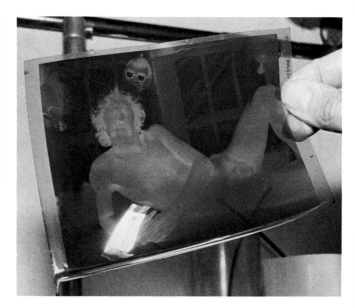

**Figure 6.**

**Figure 7.**

12.

When I print the negatives, I use Agfa Brovira paper, because it gives me a full range of tones. Recently, however, it has seemed to me that there is not as much silver in Brovira as in the past, and I'm not getting as rich a print. I've done a few things on Ilford Ilfobrom, and I anticipate working with it more in the future. I use all grades of paper, but grades No. 3 and 4 seem to work especially well for my negatives.

The prints from this portrait session are done on No. 4 Brovira paper, with some dodging on the masks and the subject's chest. I also had to burn in the background for several seconds (Figures 11 and 12).

My enlarger is a Beseler MCRX with a cold light head. I use the cold light head enlarger because it softens portraits and minimizes dust and scratches. The softening effect is due to the fluorescent light source and frosted diffuser, which even out the light. A cold light head enlarger also tends to give a longer tonal scale in the print. If I have a negative that would normally print on a No. 3 paper with a condenser enlarger, I would have to print it on a No. 4 with a cold light head. The only disadvantage of the cold light head for me is that it prints so quickly that there is little time to work with burning in and dodging. Even if I stop down to f/16, the exposures are only about 6 or 7 seconds.

My paper developer is Kodak Ektaflo. It is similar to Dektol but it is easier to use because it comes in liquid concentrate form. I use 3 oz. developer to 29 oz. water at 68 F for 2 minutes. Ektaflo comes in two forms: Type 1 for cold-toned paper and Type 2 for warm-toned. I use Type 1 because Brovira and Ilfobrom are cold-toned papers.

After developing the print, I put it into a tray containing 28% acetic acid solution for 15 seconds, and then into Kodak Ektaflo fixer for 10 minutes.

Usually I selenium tone for 5 minutes, adding 3 oz. selenium to ½ gallon Perma Wash solution. The final wash is 45 minutes in a Richardson Print Washer, a round tub-shaped washer with a circulating flow.

When I store the negatives in glassine envelopes, I often note burning and dodging instructions and paper grade for future reference (Figure 8).

One of the men I have photographed from time to time is Nehemiah (Figure 13). Nehemiah is a dancer, and I was intrigued by the outline of his body. I wanted to use the shape of his back in relation to the pattern on the Chinese silk shawl draped over the chair. The pose was inspired by Minor White's photograph of a male nude with one foot up. (NUDE FOOT, 1947, p. 78, MIRRORS, MESSAGES, MANIFESTATIONS, Aperture, Millerton, N.Y., 1969).

I was putting a black person with shiny skin against a dark background. I had to make sure his skin would pick up highlights in order to show up well. This was a difficult lighting situation. I picked the spot in the house where I

**Figure 8.**

thought the lighting was best, and then I moved the furniture around. I wanted his back to catch the reflection of the light from the window. There is not much depth of field because the exposure was made at f/11 at 1 second.

As I printed the photograph on Agfa Brovira No. 4, I burned in the background to make it completely black, so there would be no distraction. I wanted the foot to be the lightest object in the picture, and so I dodged it a little. I tried to keep the rest of the photograph down to allow the foot and the pattern of the Chinese shawl to stand out.

Although most of my portraits for the last two years have been of men, for the preceding six or seven years I worked primarily with women. I was interested in exploring my own psyche through photographing San Francisco Bay Area women, aged 20 to 40, who were involved in the arts. At last there came a point at which I had said all there was to say about a certain type of woman without stereotyping myself as an artist. Perhaps in the future I will work with women aged 45 to 60.

Twinka (Figure 14) is one of the women I have photographed most often. In this picture, I wanted the design over her head to look like a crown or headdress. I pulled a window shade down behind a curtain to create a soft back-lit situation. There was still a great deal of contrast between the background and the light falling on her face. I did not want Twinka to be completely silhouetted; therefore, I had to make sure to give her enough exposure for adequate detail. The exposure was f/22 at 1 second. I underdeveloped the negative to reduce the contrast, and to soften the light. The paper was No. 4 Brovira, with a little dodging on the face and body.

When I arranged a sitting with Cheri, I thought I would

do a straightforward, clothed portrait. Cheri wore a formal black dress, and I used various props with her, such as photographs of her parents when they were young.

I had been working with her for several hours. Towards the end of the session she suggested that perhaps I should do some nudes (Figure 15). At first I photographed her with her dogs, but it wasn't working because the dogs kept moving around. Out of desperation, I asked her to take the photograph of soldiers down from the wall over the fireplace in her house. I asked her simply to stand there holding the picture (Figure 16). It was the last shot of the day, and I thought it would be amusing.

The photograph was made in shaded daylight. She was standing in an open door. The hallway behind her was dark, except for one light on the back wall coming from the window. I prefer to stop down to f/22 or f/32 for sufficient depth of field, which meant in this case that the exposures for the session were from 1 to 8 seconds.

When I developed the film, it turned out that this was the only portrait I liked from the entire day's work. The print required some burning in on the background and a little dodging on the face.

To me, all of the people I photograph are beautiful. I realize that their looks may not fulfill the standard concept of beauty. I am attracted to them because they have something fascinating about them, a certain flair. They are people who know how to accentuate their strong points. And yet even this strength of personality is not quite enough to make a good portrait. To be effective, a portrait has to touch the viewer in some way, and it must possess some element of universal truth as well as graphic appeal.

| FILM | ASA RATING | DEVELOPER | SOLUTION & TIME | AGITATION |
| --- | --- | --- | --- | --- |
| Plus-X sheet film | 64 | Kodak HC-110 | Stock solution diluted 1:7 but varies<br><br>4.5 minutes normal<br><br>6.5 minutes<br><br>6.5 minutes | Continuous, in a 5 x 7 tray |
| Tri-X sheet film | 200 | | | |
| Ektapan sheet film | 64 | | | |

| ENLARGER | LENS | LIGHT SOURCE | USUAL APERTURE | USUAL EXPOSURE |
| --- | --- | --- | --- | --- |
| 4 x 5 MCRX Beseler | Schneider Componon-S 150mm f/5.6 | Aristo cold light D2 | f/16 | 6 to 12 seconds |

| PAPER | DEVELOPER | SOLUTION & TIME | STOP BATH | FIXER |
| --- | --- | --- | --- | --- |
| Agfa Brovira<br><br>Ilford Ilfobrom | Kodak Ektaflo Type 1 | 3 oz. Ektaflo to 29 oz. water<br><br>68 F<br><br>2 minutes | 28% acetic acid solution<br><br>15 seconds | Kodak Ektaflo<br><br>10 minutes |

| WASH | TONING | DRYING | FLATTENING | PRESENTATION |
| --- | --- | --- | --- | --- |
| 3 minutes Perma Wash solution<br><br>45 minutes in Richardson Print Washer | Selenium<br><br>½ gal. Perma Wash solution, 3 oz. selenium<br><br>5 minutes | Fiberglas screens | Stacked face to face, pressed in cold drymount press | Drymounted on 100% pure rag acid-free museum board |

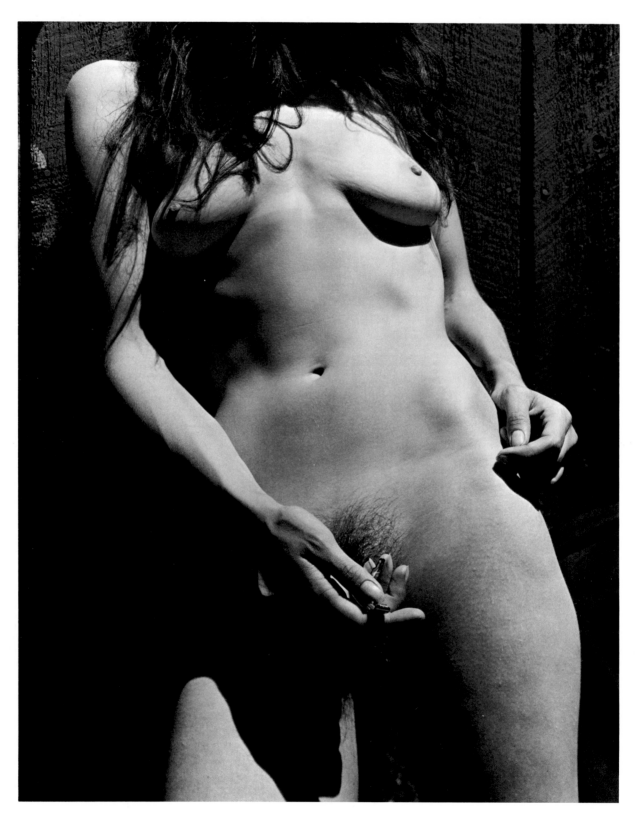

**Figure 9: Gwen, 1972**

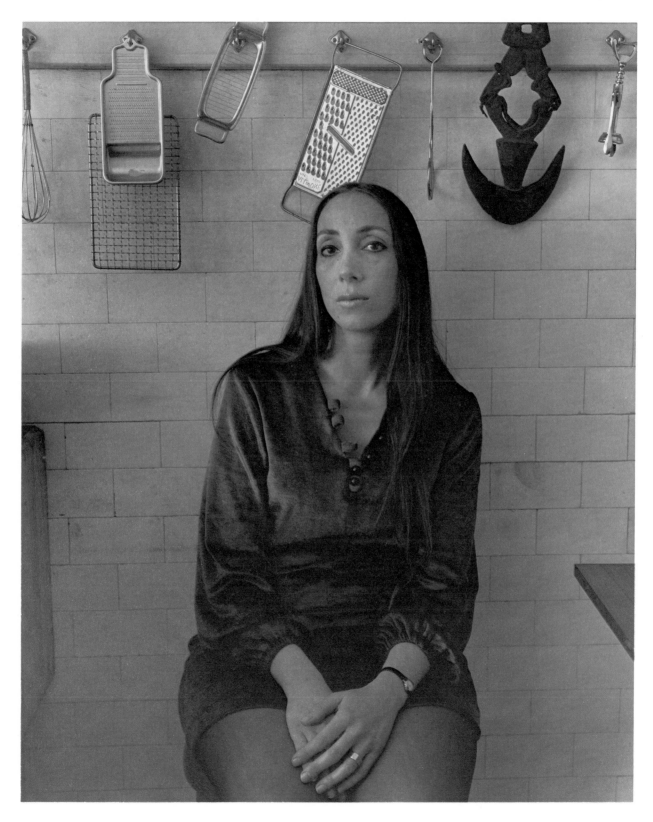

**Figure 10: Joyce Goldstein, 1969**

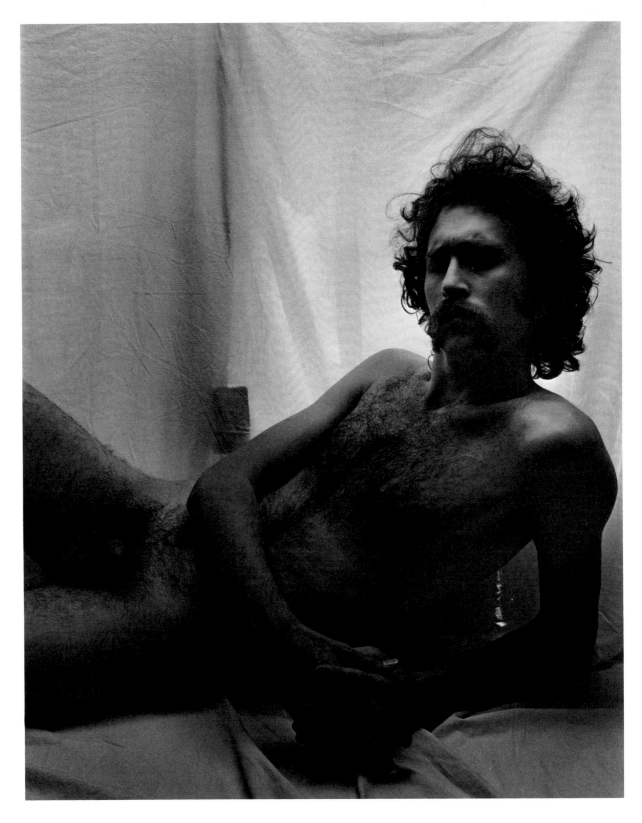

**Figure 11: Untitled, 1978**

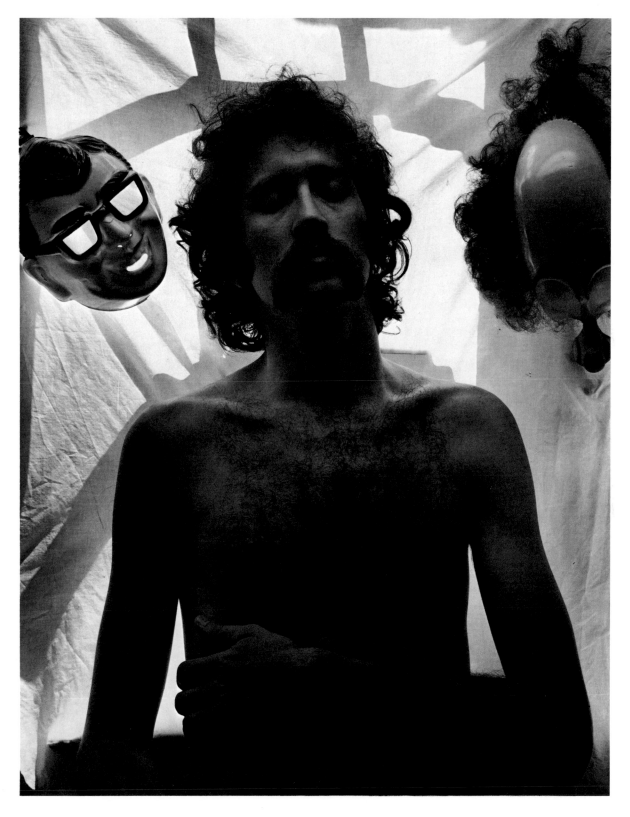

**Figure 12: Untitled, 1978**

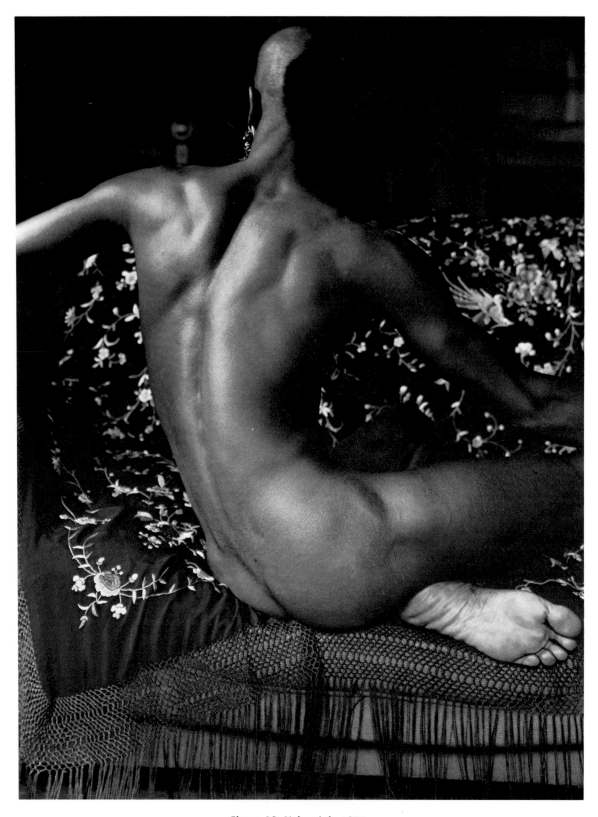

**Figure 13: Nehemiah, 1976**

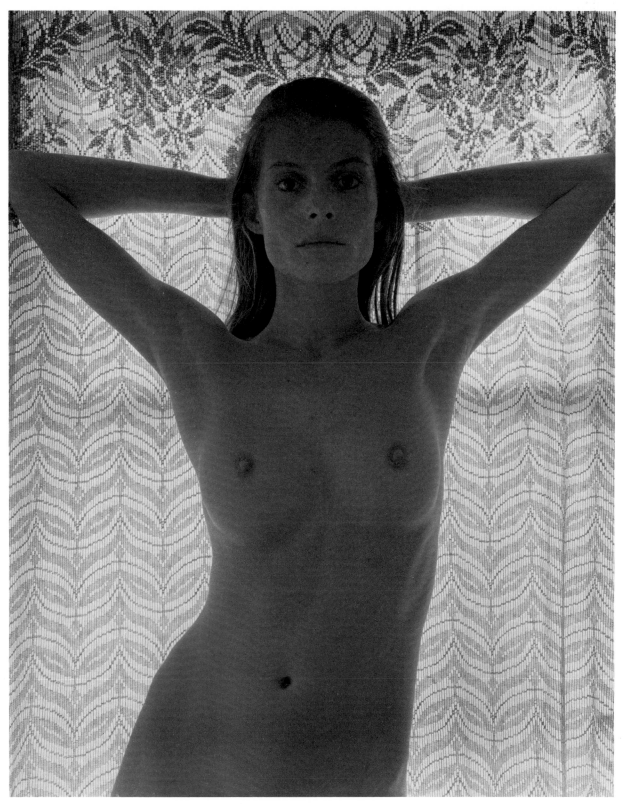

**Figure 14: Twinka, 1970**

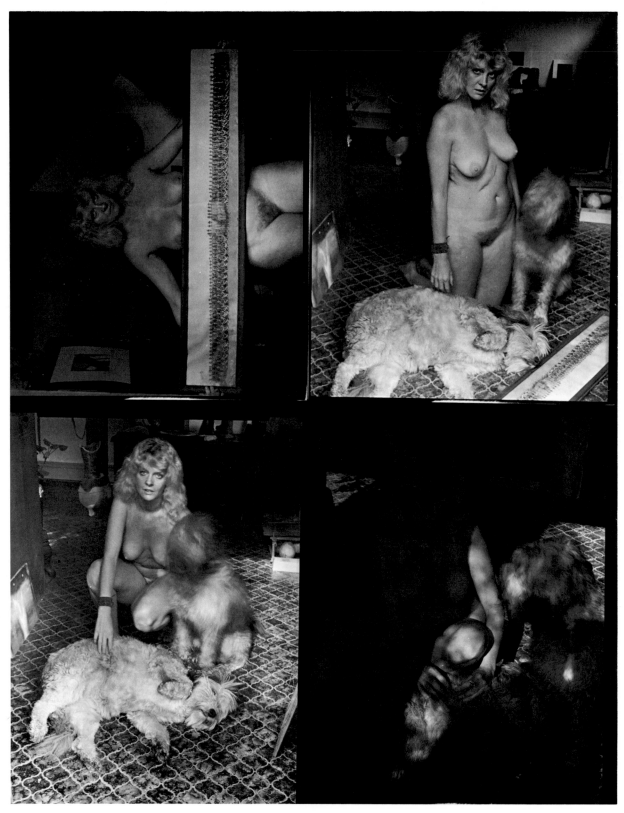

**Figure 15.**

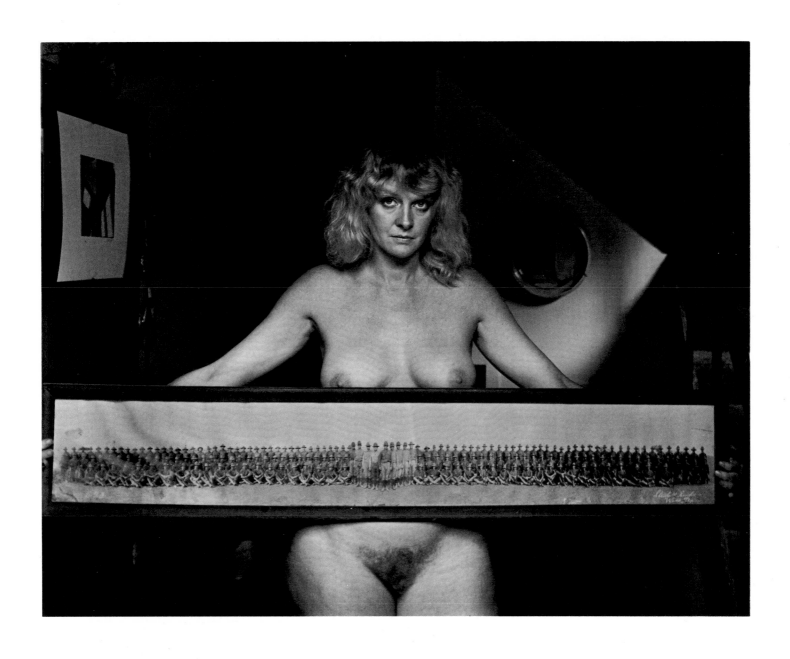

**Figure 16: Cheri, 1972**

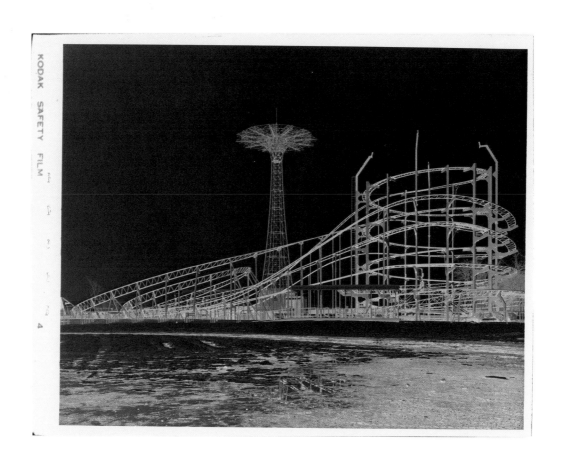

# FRANK GOHLKE

Frank Gohlke was born in Wichita Falls, Texas, in 1942. He received a BA degree in English from the University of Texas in 1964. After completing his MA degree in English at Yale University in 1966, he studied for eight months with photographer Paul Caponigro. Since then he has taught photography to many high school and college students, primarily in Minneapolis, Minn., where he lives. During the last five years he has been the recipient of fellowships from the Minnesota State Arts Council, the Guggenheim Foundation, and the National Endowment for the Arts. He participated in "The County Courthouse in America" Bicentennial Project sponsored by Joseph E. Seagram & Sons, Inc., and the Minnesota Survey Project funded by NEA.

Selected one-man shows:
1969: Middlebury College, Middlebury, Vt.
1970: Bennington College, Bennington, Vt.
1971: Underground Gallery, New York, N.Y.
1974: International Museum of Photography at George Eastman House, Rochester, N.Y.
Halsted 831 Gallery, Birmingham, Mich.
1975: Light Gallery, New York, N.Y.
Amon Carter Museum of Western Art, Ft. Worth, Tex.
1977: Boston Museum School, Boston, Mass.
1978: Light Gallery, New York, N.Y.

Selected collections:
International Museum of Photography at George Eastman House, Rochester, N.Y.
Polaroid Corporation, Cambridge, Mass.
University of New Mexico, Albuquerque, N.Mex.
Minneapolis Institute of Arts, Minneapolis, Minn.
Amon Carter Museum of Western Art, Ft. Worth, Tex.
Exchange National Bank of Chicago, Chicago, Ill.
Joseph E. Seagram & Sons, Inc., New York, N.Y.
Museum of Modern Art, New York, N.Y.

My attitude toward the world is shaped by my response to its abundance, richness and generosity. In some ways, I have a similar response to the materials used in photography. It has to do with the feeling that there is more material present in the image than can be perceived readily, and that certain images are much richer than any single encounter with them could ever reveal. The feeling carries all the way through the process. This is why it is hard to talk about technique by itself. When I am working well, I experience the integration of the physical world with the photographic process.

My camera is a 4 x 5 Linhof, which I use most often with a 135mm Symmar lens. There is something about the size of the negative that feels right. It's not that I can't get good image and grain resolution out of a small camera by using the right lens and film. It's just that the idea of exposing a piece of film as big or bigger than my hand is very important to me. I think it has to do with the relationship that a photographer builds with his materials. It's not only a matter of certain very straightforward technical decisions, but it is also a matter of what feels right. This is very hard to explain, but very important.

In my pictures, I don't make a fetish of sharpness. On the other hand, I want the image to be as sharp as possible, given the limitations of my technique. That is, I overexpose and overdevelop my negatives, which results in a slight loss in resolution. People have asked me why I don't use an 8 x 10 negative for maximum sharpness. The reason is that it is too sharp. It is one of those decisions a photographer makes as he works over a period of years, getting a sense of exactly how much detail is appropriate to the kinds of things he is trying to talk about. For some people, that might be very little detail indeed.

The difficulty in working with a large format camera lies in making it as responsive to my own body and to the world as a smaller camera. My way of doing this is to look through the detachable viewfinder. Before I even take the camera out of the case, I virtually set up my picture by looking through the viewfinder. This gives me the physical freedom to move around. In a sense, it's like having a 35mm camera which then converts magically into a 4 x 5.

Once I pick my camera position, a spot that not only looks right but feels right, I don't want to have to change it because of some small problem with alignment. This is an advantage of the viewcamera, because with it I can preserve a sense of neutrality and frontality of the image, with only minor adjustments. I use the rise and fall (Figure 1). I use the shift. Occasionally, I use the swing and a little tilt, and that's about it. Everything I've photographed for the last two years has required very little adjusting, because my subject matter is so far away.

**Figure 1.**

In some ways, the viewcamera enables me to see differently, to compose differently. Recently I had the experience of seeing my 2¼ and 4 x 5 photographs shown side by side in an exhibition. I think that by working with the 2¼ for all those years, I learned how to put a picture together. In the 4 x 5s, it became a lot easier for me to achieve what I think of as clarity of form. In part this was due to the rectangular shape of the frame, which enabled me to eliminate elements that were no longer necessary to me. It's the struggle with the necessities of the frame in relation to the world that gives a picture its energy.

I've reached the point where I rarely use a meter. I've found that the exposures I make by the seat of my pants are often more accurate than the ones I make with the meter. That is not because my meter is wrong. It's just that often I have a better feeling for what the negative is going to require than the meter.

There are situations which are genuinely confusing, especially in shadow areas when it is very difficult to determine how much light reflects off a given surface. In this case I often end up taking a meter reading after I've made the exposure, just to make sure it was correct. Usually the picture cannot be repeated at that point anyway, and so it is kind of a pointless exercise, but I do it anyway.

If I discover that a certain area of the print is going to go way off the tonal scale, I know how far I can push the materials to get the values I want. I always feel that I am at some risk in making these decisions. They are crucial, and if I make a mistake, I may lose an important picture. At the same time, when I am working well, I have an almost complete disregard for all anxiety.

I gained my ability to respond intuitively to the sensitiv-

ity of film simply by working a lot, by looking at thousands of negatives, and by being disappointed often. Finally, all the information came together: the sense of what a negative should be, the knowledge of problems in the past, the memory of what the scene was like and of what my feelings were at the time, and even the sensation of how my eyes were squinting.

Sometimes I keep notes on exposure, but usually I find them useless. I've never been very systematic. I try to work at it, but it always escapes me. My best photographs come out of the times I let go of the system.

The areas in my negatives that print black, or close to black, are still a good one and a half or two stops above Zone Zero, if I refer to the Zone System. This means I overexpose the negative. I seldom make two exposures, preferring simply to give more exposure because I've figured out the developing and printing in such a way that there is very little blocking of highlights. In printing, I can be pretty sure of bringing down any area that is too "hot."

I want a mid-range silvery scale, with minimum loss of information at both ends. I have realized more and more that what I am after, in both the image and the print, is the feeling that there is no area in which there is not accessible and significant information.

As a rule, I don't like to cut down on the development of the negative except in dire necessity, because I lose a little bit of separation in the middle tones. But a lot depends on the structure of the image. If it looks as if certain areas will be very bright and difficult to manipulate in the print, then I pull back on developing. If it will be easy to burn in bright areas, I go ahead and develop the negative normally.

When I switched from 2¼ to 4 x 5, one of the problems was to find a combination of film and developer that could give me the tonal scale I had achieved in my 120 work. With the 2¼, I could use Verichrome Pan, the best film Kodak every made. But it is available only in roll film.

After experimenting, I found that the simplest solution was the best one. I settled on Kodak Plus-X sheet film with a heavy exposure, and developed it in Kodak HC-110, in a higher than recommended dilution, but for a greater length of time. I have a very dense and fairly contrasty negative with almost no clear film in the image itself.

When I was printing on du Pont Varilour paper, my normal print was on a grade No. 1 paper. When they stopped making Varilour, I had to find another paper, and I finally settled on Kodak Polycontrast Rapid with no filter, which is about equivalent to grade No. 1½.

I use a soft print developer, Dektol 1:3, with some Metol, which softens the image just a bit more. I mix up a gallon or two of straight Dektol stock solution at a time, which I can leave on the shelf. When I am ready to print, I add two teaspoons of Metol to a quart of straight Dektol, and then I add enough water to make a 1:3 dilution. I don't mix the Metol into the stock solution left on the shelf because I suspect there may be some deterioration. To guard against it, I would probably have to add a preservative to the stock solution, and that would probably throw something else off. Everything considered, it's easier to add the Metol when I set up to print. The Metol brings the shadows up very quickly after the print goes into the tray, where I develop it for three minutes.

To summarize, I work on a soft paper with a soft developer and an overexposed negative. The combination gives me a medium scale compatible with my imagery.

I used to print my 4 x 5 negatives with a cold light head enlarger. Then I discovered that the reason I had to burn in the corners so much was that the diffuser on a cold light head enlarger does not permit the light to cover the negative completely. Now I use a condenser head, which adds a little contrast I couldn't get otherwise.

Figuring all this out is like fine-tuning an engine. I think of all my technical processes as links in a very complicated chain. I have to add some contrast here, and take some away there, to get the scale I need. I add contrast in the development and printing of the negative, and then I take it away in the development of the print. It took me the better part of six months to figure out my system in relation to Polycontrast Rapid paper.

Very few of my prints require extensive manipulation in the darkroom. In CONEY ISLAND (Figure 9), the problem was simply to make small adjustments (Figures 2 and 3). When I exposed the negative (Figure 4), it was a clear day, with just the last rays of sunlight. To my eye, the sky was a very deep blue, but in a black-and-white photograph, it becomes very bright. This is exactly what I wanted to show the forms and structures against the horizon.

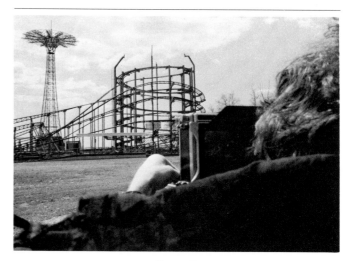

**Figure 2.**

**Figure 3.**

**Figure 4.**

When I made the print, I tried to get a sense of the sky growing brighter on the right side, as it does late in the afternoon. I tried burning in a little bit in the lower left-hand corner, and dodging the lower right-hand corner. Neither adjustment was really right. It turned out that the best way was to print the negative straight, with some work in the upper right-hand corner. My overall exposure on the paper was 18 seconds at $f/16$, with 16 seconds added in the upper right. When the negative has great density, I have to burn in a lot to get a perceptible effect.

When I was exposing the negative (Figure 5) for POWER PLANT (Figure 8), I wanted enough density in the shadow areas, which I knew were way off the scale in relation to the sky, the bright smoke stacks, and the crane. I wanted to bring up all of the detail in the lower left-hand corner, but with plenty of separation, while retaining deep shadow.

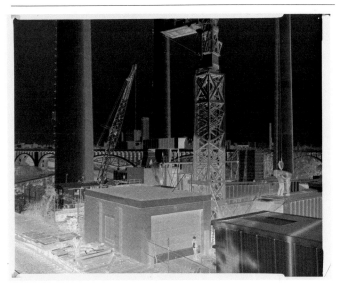

**Figure 5.**

I didn't have to get involved with tilts and swings because everything was a considerable distance away. I looked <u>through</u> the ground glass and not at it, a technique that the viewcamera photographer must learn. I focused at about ⅓ the distance in order to get maximum depth of field, and stopped down.

To develop the negative I diluted HC-110 stock solution 1:10. Then I underdeveloped the negative by about ½ stop. It works out that a full stop underdevelopment requires about 30% less time, so I underdeveloped this negative by about 15%.

When I made the first print (Figure 7), I gave an overall exposure of 8 seconds, although I dodged the lower left-hand shadow area for the last 1½ seconds. I burned in the lower right-hand corner for 11 seconds, about ⅓ more time. The entire upper fifth of the print got an extra second, and the corners also received a couple of seconds more.

When I examined the first print, I was unhappy that the bands running around the center smoke stack were getting a bit lost. So I gave the upper part of the picture an extra second, while holding back 1½ seconds in the lower left-hand corner. But then the lower left-hand corner got too bright, so I had to burn it back in (Figure 6).

In the final print, the upper third of the picture got 9 seconds, but the large box was held 2 seconds less, to bring the figure up. I dodged the triangle at the lower left for 2 seconds, so that it had a total of 5 seconds exposure. I burned in for an extra 2 seconds in the extreme lower

left-hand corner (Figure 8).

**Figure 6: Burning and dodging notation**

The picture MET STADIUM (Figure 10) gave me a little trouble while I was taking it. The atmospheric haze that day had made the stadium very, very gray. There are a lot of shadows underneath the bleachers that I expected to be black. But they weren't printing black. I realized that there is just a little black between each slab of concrete at the bottom of the picture, in the foreground, just enough to carry the scale. So, when the viewer looks at the print, he attributes the gray of the stadium and of the shadows to distance, rather than to weak printing.

Everything is resolved very nicely, with the clouds just barely up there in the sky. They give me so much pleasure. They're why I expose the way I do. I like the feeling of those clouds that are just barely there in those bright skies.

I have a theory that is probably half-baked from a technical standpoint: to get the best results, I have to throw as much light and chemical action as possible onto the materials. The more I use of what is in the paper and the developer, the more expressive I can be. It is a matter of preserving as much silver as possible. I bet I could polish it. I think there are nearly imperceptible things in the image, like the clouds, that the viewer has a great deal of difficulty seeing on the paper. Perhaps he can't see them at all, but somehow he feels them. There are details that the photographer knows exist in the negative, but in the print they are so close to the outer limit of perception that they could almost be said not to exist. But they do make a difference.

| FILM | ASA RATING | DEVELOPER | SOLUTION & TIME | AGITATION |
|---|---|---|---|---|
| Plus-X sheet film | 50 | HC-110 | Stock solution diluted 1:10, but varies<br><br>68 F<br><br>5½ minutes | Continuous in tray |

| ENLARGER | LENS | LIGHT SOURCE | USUAL APERTURE | USUAL EXPOSURE |
|---|---|---|---|---|
| 4 x 5 MCRX Beseler | E1-Nikkor 150mm f/5.6 | 212 | f/16 | 10 to 20 seconds |

| PAPER | DEVELOPER | SOLUTION & TIME | STOP BATH | FIXER |
|---|---|---|---|---|
| Polycontrast Rapid F | Dektol | 1:3<br><br>3 minutes<br><br>72 F<br><br>(2 tsp. Metol per qt. straight Dektol) | Glacial acetic acid<br><br>1 oz. per gal.<br><br>15 to 30 seconds | Kodak<br><br>2 baths<br>bath 1: 3 to 5 minutes<br>(then hold in tray wash approx. 10 mins.)<br>bath 2: 5 minutes |

| WASH | TONING | DRYING | FLATTENING | PRESENTATION |
|---|---|---|---|---|
| Final wash 1 to 1½ hours<br><br>75 F | 4 oz. Hustler Rapid Bath<br>4 oz. selenium<br>25 grams Kodalk Balanced Alkali per gallon solution<br><br>7 to 8 minutes<br><br>80 F | Fiberglas screens | Dampen back of print with sponge; press between 2 pieces of 100% rag board in drymount press<br><br>200 F | Unmounted; placed in 100% acid-free pure rag overmattes |

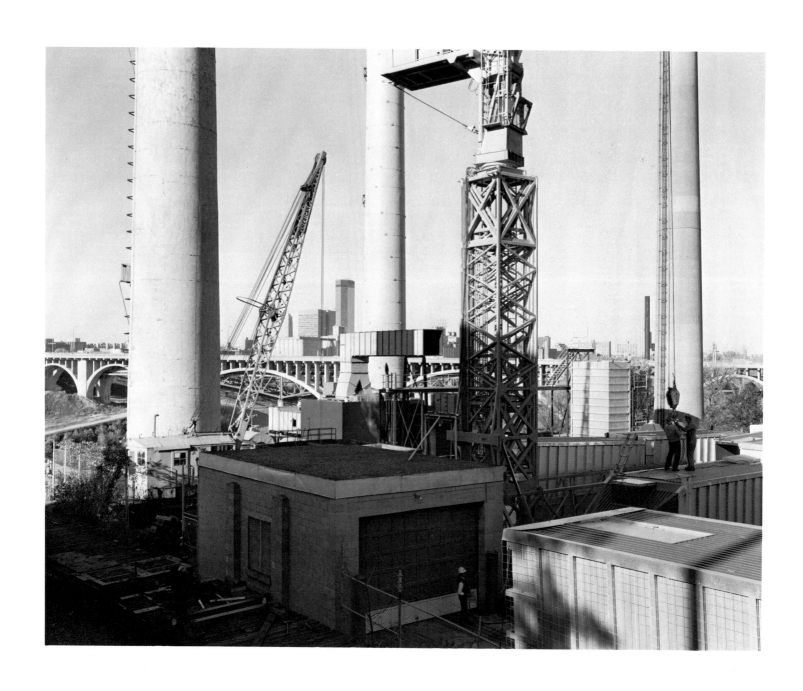

Figure 7: POWER PLANT, MINNEAPOLIS, MINNESOTA, 1977

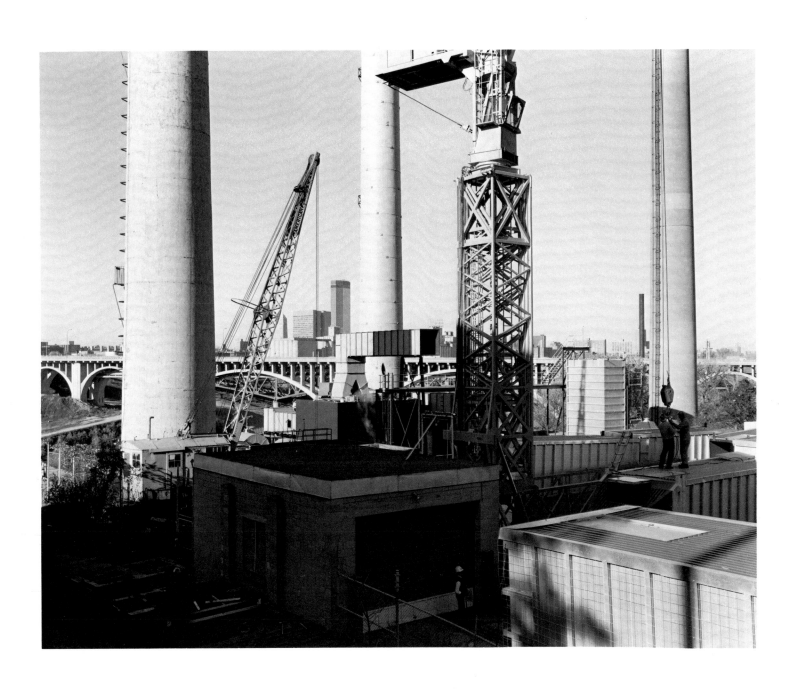

Figure 8: **POWER PLANT, MINNEAPOLIS, MINNESOTA, 1977 (Final version)**

**Figure 9: CONEY ISLAND, BROOKLYN, 1978**

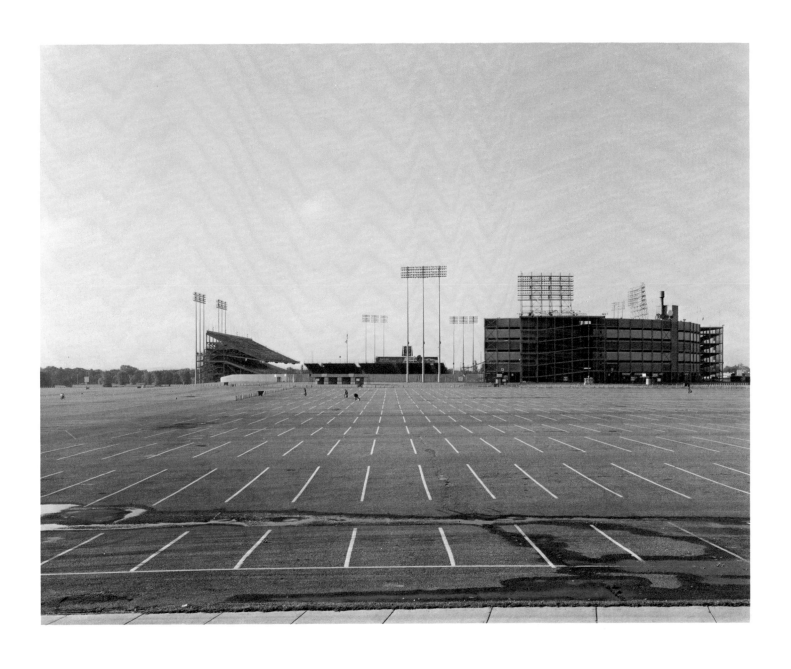

**Figure 10: MET STADIUM, BLOOMINGTON, MINNESOTA, 1977**

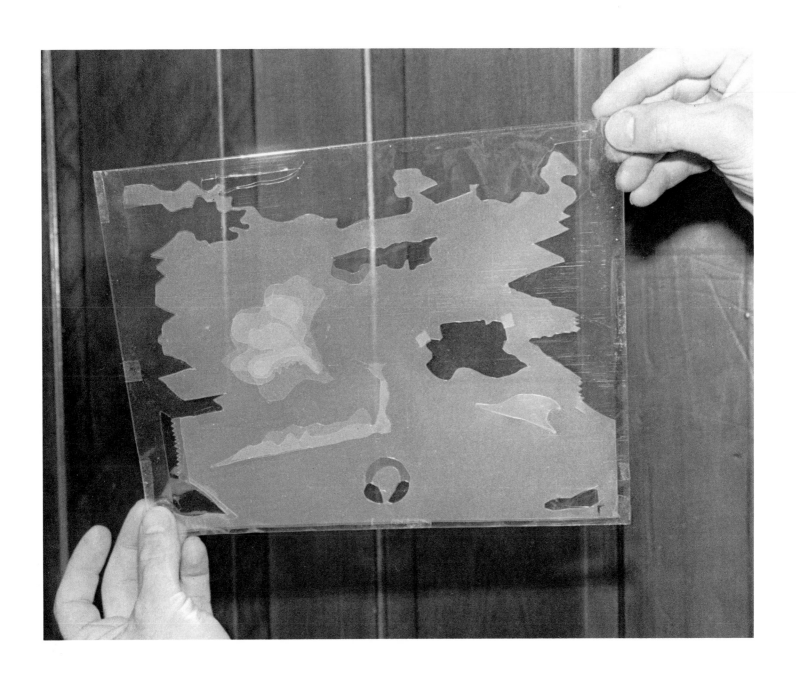

# EMMET GOWIN

A Light Transmission Contour Pack for Photographic Printing Control

The light distribution on a print can be represented by a contour
map in the same way that elevations in terrain are represented on a topographic map.

---

The characteristic way in which a negative distributes light on photographic paper
may need to be modified in making an effective print.

---

A precise and repeatable way of doing this is to lay over
the negative translucent sheets cut as stepped contours which selectively add to
the density of the negative, reshaping its light transmission
characteristics to the desired distribution.

---

First, a contour map is drawn on a piece of clear plastic laid over a proof print to
demark areas according to the amount of light adjustment they require.

---

Next, one translucent sheet is made for each light adjustment
increment represented on the map by cutting the sheet along all contour
lines corresponding to that increment.

---

The sheets are then registered and fastened to a clear support,
completing the light transmission contour pack.

---

When making a print, a diffusing surface is placed between the pack of sheets and the
negative to insure continuous distribution of light on the printing paper.

---

Frederick Sommer
Alexander Jamison

Let me just talk to you from my feelings, first about my beginnings, then about technique. My belief is that we have lived so long in the world with pictures of all kinds, but especially photographs, that we have no idea of what it would be like without them. Such a great deal of our experience came to us through photographs.

I remember precisely, a moment in the late fifties, turning the pages of LIFE Magazine, and realizing that when the trees were cut down and turned into pulp, and when the pulp was made into paper, and when the paper came rolling out of the machines, it hit me, these pictures were not already there. They had somehow to get onto the paper. They did not, like growth rings, come out of the tree, like some mystery found. They had to be put into existence; they had to be made.

This was a fairly innocent realization but it is complementary to the fact that so much of the time we spend photographing pays homage to the fact that the camera works with blessed assurance, before we can completely realize what we are doing. Its action is quicker than our thought and as a result some marvelous surprises <u>do</u> occur, quite beyond our intentions.

But that's just one side of the issue. The other side is that a person must make these images. I am thinking now of Walker Evans' wonderful idea that when different people use this machine, the results can be as distinct as fingerprints; we can sense the feeling that they made.

The challenge of photography is to show the thing photographed so that our feelings are awakened and hidden aspects are revealed to us. Victor Shklovsky in ART AS TECHNIQUE, writes: "In order to restore to us the sensation of life. . . art uses two techniques: the defamiliarization of things, and the distortion of form, so as to make the act of perception more difficult and to prolong its duration." (p. 12, RUSSIAN FORMALIST CRITICISM: FOUR ESSAYS, translated by Lee T. Lemon and Marion J. Reis, University of Nebraska Press, Lincoln, Neb., 1965).

I'm borrowing freely from other people. I'm just not making this up, any more than I could have made up the origin of pictures. I arrived at the realization that a photograph is not directly a by-product of trees. Likewise, our understanding does not simply materialize; there is evidence, and there are events and sources involved.

Now, perhaps the next step was to realize that a photograph is something symbolic. It isn't even a surrogate "thing;" the thing photographed may not be important at all. A tree doesn't need the photograph to exist as a tree. What we are making is not another tree, but a photograph, and this is a very different operation, a symbolic operation, like writing down a mathematical equation or making a sentence. The words in a sentence say to the world what we remember; they touch the world again, and yet are not

attached to it rigidly. The painter René Magritte conveyed the idea that we can't imagine that any single meaning is attached to any single word so strongly that we cannot attach other meanings to the same word. But exact arrangements of language or exact display in pictures connect more precisely with our feelings; they feel right or true or they do not. This indicates that we are sensitive to exact arrangement in images, and that "meaning" and "feeling," although very elastic in interpretation, are anchored in the precise interrelationships which constitute structure.

Although I didn't know how to say this for a long time, once I realized that pictures are wonderful because they are made, because they are imbued with the feeling of the person making them, and because they are symbolic (something quite different from that which is simply represented) then I was interested.

I knew I was interested, but I didn't know what kind of pictures to make. I could not know until I had searched out other pictures, many of them photographs. I was going by feel and I don't think I could have described the process I was involved in. Still, I found a picture that moved me very strongly, and I carried a camera until I found a situation in nature that was very close to the thing I admired.

Later I heard the photographer Frederick Sommer say that images are about images. This statement had a beauty for me because it provided an expression for what I had experienced. Intuitively, I knew that I was working with the way we experience things arranged in pictures. Pictures are a type of experience that belongs to a particular world. We don't realize we are arranging the world until we have seen enough pictures. So, the first pictures I made naturally looked something like what I admired. This is still true: whatever interests me will always have an influence on what I produce next.

Let me give a further illustration about the importance of appreciating your own sources. In a workshop last spring, I asked students who were presenting their work to show me two pictures: the one they admired most, their best work, and the one that most reflected their model, their source. I wanted them to cut down from 30 pictures to just two. There was no problem in identifying the favorite; they just had to point and say, "This is my favorite." But there was a general difficulty in naming a favorite source or inspiration, although most of these pictures suggested some possible influences. We weren't able to go very far with this motif, because we cannot let ourselves say what is really obvious. But, I realized in that instant the trouble we have is not that we can't say what we are doing; the problem is that we can do only what we can say. Our pictures are only of what we are talking and thinking about, whether or not we try to disguise the fact that we are being influenced. I believe that our pictures are lived before they become pictures.

I very much appreciate this statement by Claude Lévi-Strauss: "Individual human beings (whether at play, in their dreams, or in moments of delirium) never create absolutely." In a more subtle way Lévi-Strauss continues this thought when he says, "Whoever says man, means language; and whoever says language, means society." (pp. 160 and 389, TRISTES TROPIQUES, translated by John Russell, Criterion Books, N.Y., 1961). I do not want to say there is no originality; there is. Simply, we cannot leave our lives and go someplace else. Having left all models behind, we would not be able to find ourselves, nor recognize anything when we got to where we were going. So if I am alive to the next minute, it will be filtered through what I have experienced.

As a youngster, I didn't read that much or study either. It was how pictures look that gave me a basis for my work. My introduction to painting and art history came when I was an undergraduate in Virginia, and has been extremely important to me. I want my connections to be ancient ones. I feel as close to early Italian painting and the Northern Expressionism of the Renaissance, as I am to any particular notion that I will know how to photograph a given situation the next time one comes along. Of course you must do your homework, and perhaps this is just a mood I like to cultivate, but I want to be thinking about more than photography. I want to mirror in the work I produce the feeling that stimulated me to think working was worthwhile; it has to do with a density of implication and the intensity of feeling that I recognize in the works of Bruegel the Elder, Hieronymus Bosch, and Albrecht Dürer.

This morning it occurred to me it would be useful to compare the underpainting procedure of the Renaissance egg tempera technique to the process of mapping out a printing procedure for photographs. Simply, a photograph is a map that in a fixed way shows where things are. If in printing a photograph we feel the need to adjust anything, we learn this from the photograph itself. In Renaissance painting the positioning of objects was established before the actual painting was begun. Drawings and preliminary sketches were made. These drawings were then assembled into a complete plan or "cartoon," which was transferred to a painting surface. Position was refined and weights of dark and light assigned to the positions which the subjects had been given. In the "unfinished" painting by Leonardo da Vinci, THE ADORATION OF THE MAGI (Figure 1), we can examine this stage. The objects in this painting are not filled in completely and many people speak of the painting as unfinished. In addition, the figures are not all positioned in a way possible for animals and people in a real world. But these positions are not illogical in terms of the total picture. Leonardo had only "mapped in" or dia-

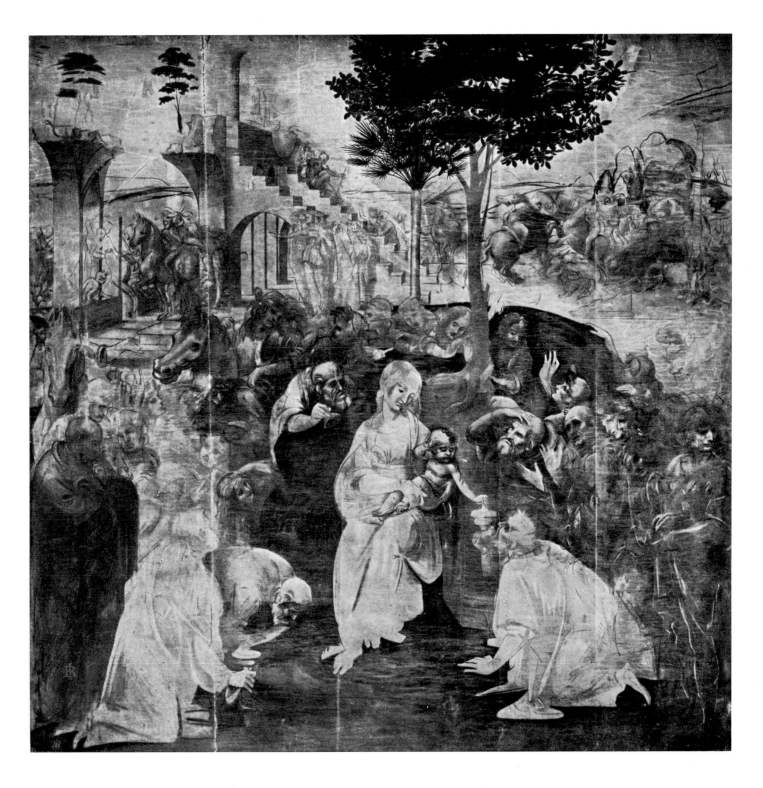

**Figure 1: THE ADORATION OF THE MAGI, by Leonardo da Vinci**

gramed the elements of his picture when he stopped painting. But the feeling of many is that the artist had already placed everything beautifully; the objects didn't need to be colored in.

One of the essential characteristics of photography is that it doesn't like to leave out anything. Scientists and mathematicians too must accept a complete world in which features can only be isolated temporarily. Then they deal in procedures which either separate or bring things together. The photographic surface can either be completely exposed, or completely blank, or somewhere in between. We can expose a photograph more, or less. The intensity of light in the area links to the intensities next to it; this transition has always been an important concern of art. In printing we work to clarify the boundaries. As we bring adjacent values together, tension increases as well as the risk of losing discrimination. Subjects also link through proximity, and thus fixed can imply an entire history of experience. Think for a moment of the wonderful photographs of Cartier-Bresson or Robert Frank.

Now, as I see it, photographic printing works this way: we can increase the contrast of an image very easily, but we have one heck of a time decreasing it. The nature of film is that if we underexpose it, we can never bring back more detail or image at a later step. We can remove silver later (bleach or reduce) but even intensification only changes contrast and can only add to a structure which is already there. So I want a negative with separation across a long scale without underexposure. The traditional rule of exposing for the shadows and developing for the highlights remains useful for it expresses the basic nature of the process. Several good texts explore this principle in detail: THE NEW ZONE SYSTEM MANUAL by White, Zakia and Lorenz (Morgan and Morgan, Dobbs Ferry, N.Y., 1976); THE ZONE VI WORKSHOP by Fred Picker (Amphoto, Garden City, N.Y., 1974); and the ANSEL ADAMS BASIC PHOTO SERIES (New York Graphic Society, Boston, Mass., 1977, distributed by Little, Brown and Co., New York). All may be examined freely without buying stock in any particular style.

It is to our advantage not to overdevelop the film, for excessive contrast in the negative is the most difficult problem in printing. Because I want to preserve or even intensify separation in the print, I often attempt to increase the contrast locally while subduing the contrast overall. This usually means using the next higher contrast grade of paper and using a lower contrast developer. Kodak's Selectol-Soft or its equivalent is excellent for this purpose. The reverse of this procedure also works but I use it less.

When I first started getting sensitive to printing, I often prepared four developer trays for a darkroom session: one with a plain water bath, one with Kodak Dektol, one with Kodak Selectol-Soft, and one with Amidol. Each has differ-ent characteristics of speed, color, and contrast. I learned the use of Amidol from my friend Jim Dow. He refined this formula and its use while he was printing for Walker Evans. The formula is: 30 grams of sodium sulfite, 5 to 9 grams of Amidol (I use 6), and .6 gram of potassium bromide, dissolved in that order in one liter of water at a working temperature of 68 to 70 F. The use of Amidol with a short initial development followed by a longer water bath is excellent in reducing contrast by subtle degrees.

In these early days, when I worked with these three developers, plus water, I tested each print in the different solutions. If I found a characteristic that suited a different kind of negative, I took advantage of this by finding another negative which more closely matched the quality of the developer. This taught me that each negative and each print was in some way individual.

The grades of photographic paper are rarely exactly right. So I have to split grades. Sometimes the only way to get the correct weight and color in a print is to divide the development time between two developers: Dektol and Selectol-Soft, for instance. Visually this may approximate grade No. 2 while it is in fact grade No. 3, but the separation between middle values is usually increased.

Even when I adjust contrast in the way described, the burning in and dodging is often a separate, complex problem. Sometimes it takes fifteen minutes to expose a single print. I am in the habit of drawing a diagram or map of the picture and labeling in the parts where extra exposure or manipulations are required. These maps may be referred to later although each printing must remain fresh to remain interesting.

In spite of great care, I have made some very dumb mistakes. This is balanced in that most invention occurs with the most difficult prints. A particularly difficult negative might have an exposure range of 1-16 in printing, or 5 f/ stops, and require extensive manipulation. Of course, I would prefer to have perfect negatives but I would not hesitate to over-print a local area from another negative, or double print, or to graft images together.

One of the things I discovered when enlarging 2¼ negatives of subtle transparency was that I couldn't print on regular enlarging paper. Its sensitivity is so great that the threshold of minimum exposure was crossed too quickly. This led to enlarging on Kodak Azo paper, a very slow paper normally used only for contact printing. The prints it produced might have been attempted on grades No. 5 or 6 enlarging paper, but were even more open and transparent when enlarged on grade No. 3 Azo. Of course there are limitations to this procedure and one must feel forced to use it. At least 250 watts of light are needed; the exposure is often one minute long even with the perfect negative; and maintaining sharpness in even a small print

is not always easy. Still, I got a marvelously clean chemical transparency in these prints and I learned there's nothing wrong with a fine range of middle grays.

The mystery of a beautiful photograph really is revealed when nothing is obscured. We recognize that nothing has been withheld from us, so that we must complete its meaning. We are returned, it seems directly, to the sense and smell of its origin.

We can imagine how a print can be improved only by knowing what is wrong with it. We might also ask: when is a print complete? In a way, we don't know the point at which we have finished. If we think we have reached that point, we stop. If, later, we still see more possibilities, then we have reason to go back and print again.

A complete print is simply a fixed set of relationships, which accommodates its parts as well as our feelings. Clusters of stars in the sky are formed by us into constellations. Perhaps I feel that this constellation has enough stars, and doesn't need any more. This grouping is complete. It feels right. Feeling, alone, tells us when a print is complete.

Frederick Sommer once spoke to me: "When nothing is found again and the dead have settled only their chances then in the noon of the solemnity of every hour life returns."

This ability to recognize completeness must be developed, and is the same intuitive power that one brings to organizing the negative. When I say I can't print a negative, what I really mean is that a feeling of completeness can't be nurtured from it; I can't bring it into an alive balance. I may also lack a rich subject. Richness of subject, of implication and tension within equilibrium, are some of the attributes of art. A lot of pictures just aren't that good, no matter how much work we lavish on them. I must discard a lot. But I would prefer to reduce the number of images I make in favor of intensity of feeling. Thus editing is a strict aspect of the craft.

Finally, some thoughts on the illustrations: perhaps even the best lenses deliver less light at the edges of a negative. With older lenses this was often the case, so that photographers came into the habit of "burning in the edges." That is a touch of cowboy logic; fence it in. Also, because we think the thing is escaping from us, we like this security; we don't want it to go over the hill and get away. When, by 1967, I had begun to work with a 90mm Angulon on an 8x10 Eastman camera, this was the last thing I wanted to achieve. I had already made it a habit to attempt to use the entire frame, filled, if possible, with interesting information. Thus when I continued to produce a series of circular pictures within a black rectangle, I often longed for more subtle transitions and even attempted multiple exposure to enrich this outer frame. The photograph illustrated, VIEW OF RENNIE BOOHER'S HOUSE, DANVILLE, VIRGINIA, 1973 (Figure 2), was the first to require this solution.

Printed straight, the illumination was about three f/stops less at the edge of the circle and the black frame depressed the landscape even further. The final solution was quite simple although it took me several months to resolve.

The negative is clear beyond the circle. Eventually, I cut a set of simple matte-board templates, using various-sized dinner plates as guides. These are hand-held above the negative while the center is being printed. Progressively smaller circles are used during the main exposure and a small amount of the exposure is reserved for the whole negative. This last few seconds determines the tone of the gray outside the circle. The print is still not an easy one, meaning that several prints must be made to get a single successful one, but the landscape is more convex, more expansive, surrounded by this soft grayness (Figure 3).

The photograph SIENA, ITALY, 1975 DEDICATED TO FREDERICK SOMMER: THE HINT THAT IS A GARDEN (its complete if longer than usual title) is dedicated beyond the fact that his procedure is used in its printing and it is being illustrated here (Figures 4 and 5). His influence can be felt throughout this discussion.

**Contact print of Figure 5 from contour printing pack (reduced)**

The technique of making a "contour printing map" is a collaboration between Frederick Sommer and his apprentice of four years, Alex Jamison. Since their description is reprinted here in full, I will make only a few comments.

I believe I learned about this approach during a phone conversation with Fred. Within the next few days I made quite a good "map" of another negative. It was not perfect, but I knew it would work. It would, in fact, greatly improve some pictures. A year later, after seeing a "contour printing map" which Alex had prepared, I realized that there were differences in our registration and other simple mechanics, but the principle was elegant enough to sustain variety

and still work. Working from a straight 8x10 proof print, I cut the "contour printing map" for SIENA landscape in about an hour on a Christmas afternoon.

Aspects of this procedure are not new. Older photographers took advantage of various masking procedures: putting rouge on the glass side of their plate negatives was one. Walker Evans once mentioned putting bits of pale-colored film or paper behind the glass of an old fashioned contact printer to reduce the light reaching crucial areas of the negative. What is both fresh and original is the appreciation of the likeness between the distribution of light in a photographic negative and the representation of elevation and configuration in topographical maps. Once made, this association of the photograph with maps is both evocative and useful.

Finally, now that I have used the method on five or six successful prints, I realize its second beauty is that it can be used to illustrate just what decisions were made. Its greatest value to most photographers may be in displaying exactly the degree of change which our feelings require.

**Contour map of Figure 5 drawn on clear plastic (reduced)**

| FILM | ASA RATING | DEVELOPER | SOLUTION & TIME | AGITATION |
|---|---|---|---|---|
| Tri-X | 200 | Tri-X 120 Microdol-X ——— D-23 ——— Tri-X 8x10 HC-110 | Undiluted with replenishment ——— undiluted with Kodalk ——— 32 oz. water to 30 cc concentrate ——— cf. Ansel Adams, Minor White | Continuous per film instruction sheet |

| ENLARGER | LENS | LIGHT SOURCE | USUAL APERTURE | USUAL EXPOSURE |
|---|---|---|---|---|
| None | None | 75 watt light bulb | None | Minimum black time ——— 10 seconds |

| PAPER | DEVELOPER | SOLUTION & TIME | STOP BATH | FIXER |
|---|---|---|---|---|
| Azo ——— Portriga Rapid ——— Polycontrast | Amidol ——— Selectol-Soft ——— Dektol ——— Ansco 130 (glycin without hydroquinone) | Variable (i.e., development often split among 2 or more solutions) | 28% acetic acid solution | NH 5 concentrate diluted for paper ——— 2 baths |

| WASH | TONING | DRYING | FLATTENING | PRESENTATION |
|---|---|---|---|---|
| Perma Wash Solution ——— East Street Gallery Washer ——— 1 hour | Selenium ——— gold ——— tone for effects of separation | Air dry from clothes lines | Agfa, heat flattened | Unmounted, placed in 100% pure rag acid-free museum board overmattes |

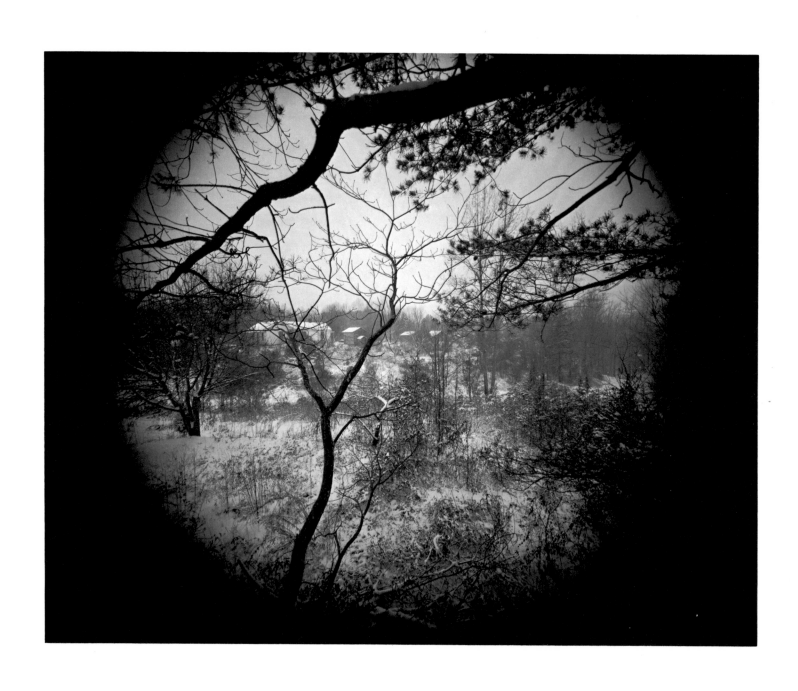

**Figure 2: VIEW OF RENNIE BOOHER'S HOUSE, DANVILLE, VIRGINIA, 1973 (Version 1)**

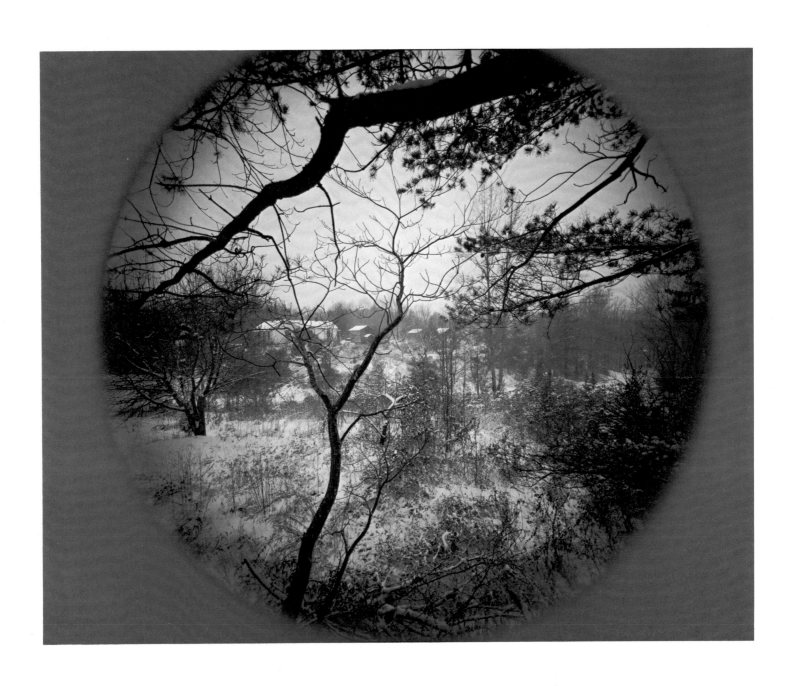

**Figure 3: VIEW OF RENNIE BOOHER'S HOUSE, DANVILLE, VIRGINIA, 1973 (Version 2)**

**Figure 4: SIENA, ITALY, 1975 DEDICATED TO FREDERICK SOMMER: THE HINT THAT IS A GARDEN (Version 1) Made without contour printing pack**

Figure 5: SIENA, ITALY, 1975 DEDICATED TO FREDERICK SOMMER: THE HINT THAT IS A GARDEN (Version 2) Made with contour printing pack

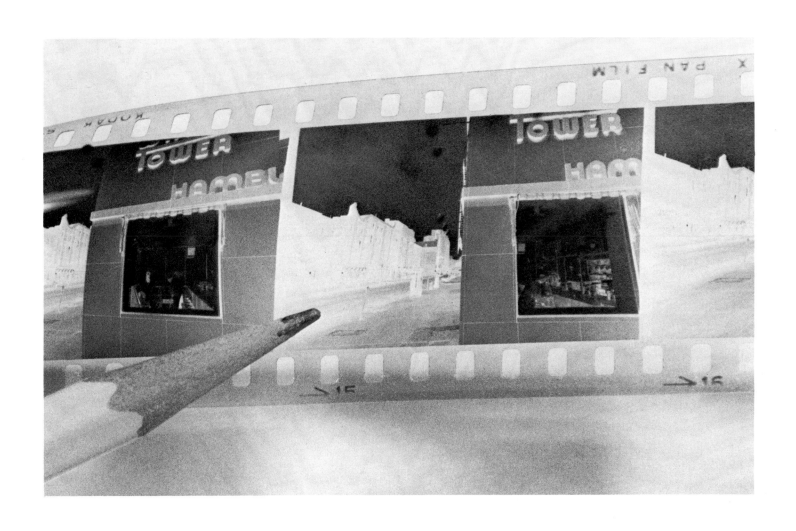

# CHARLES HARBUTT

Charles Harbutt was born in Camden, New Jersey, in 1935. Following his graduation from Marquette University's College of Journalism in 1956, he wrote and photographed as associate editor of JUBILEE Magazine. In January, 1959, he took part in a three-month project to document the Cuban Revolution.

For the next three years he worked as a free-lance magazine photographer in New York City. He joined Magnum Photos in 1963. During his association with Magnum, he has photographed for LIFE, LOOK, NEWSWEEK, PARIS MATCH and STERN; covered major U.S. elections, the 1967 Arab-Israeli War, and the peace movement. He has served as president of Magnum Photos twice.

Harbutt has taught photography students all over the world. In 1978 he was visiting artist at MIT.

Harbutt's book TRAVELOG (MIT Press, Cambridge, Mass.) won the Arles award for the best photography book of the year in 1974.

Selected one-man shows:
1965: Art Institute of Chicago, Chicago, Ill.
1974: Il Diaframma, Milan, Italy
1975: Photographers' Gallery, London, England
1976: Panopticon, Boston, Mass.
Bennington College, Bennington, Vt.
Art Institute, Kalamazoo, Mich.
1977: Galerie Fiolet, Amsterdam, Holland
Infinite Eye, Milwaukee, Wisc.
1978: Simon Lowinsky Gallery, San Francisco, Calif.
Plains Art Museum, Moorhead, Minn. (two-man exhibition with Andre Kertesz)

Selected collections:
Smithsonian Institution, Washington, D. C.
Bibliothèque Nationale, Paris, France
Museum of Modern Art, New York, N.Y.
Princeton University, Princeton, N.J.
Exchange National Bank, Chicago, Ill.
New Orleans Museum of Art, New Orleans, La.
San Francisco Museum of Art, San Francisco, Calif.
Moderna Museet, Stockholm, Sweden

JOAN LIFTON

I work in sort of an off-the-wall manner. I shoot by whim; I don't really go out with specific ideas. After I develop the negatives, I decide if I like a picture, and if I want to print it. I don't previsualize the print because I feel it gets in the way of a more spontaneous relationship to the subject.

My technique involves being as uninhibited and as quick as possible while I am shooting pictures, and then spending time and being patient in the darkroom. The question I ask about a photograph is whether or not the print is right for the negative, not whether the photograph is right according to some abstract ideal of perfection.

For me, printing is a way of finding out what a picture is about. I don't know if a photographer ever really finds out what his best pictures are about. The choices I make in printing (lighten this, darken that) begin to tell me what my priorities are, what I want to see more clearly, what I want people to look at. The final print is a crystallization of all of my feelings about the image. Sometimes I think of myself as "jousting" with the image in the darkroom; the negative calls for moments of risk, adventure and endurance on its way to becoming a print.

I used to use the word "chocolate" to describe my prints. I wanted a chocolatey print, which basically has to do with a low tonal range, and good separation in the darks. My idea was that by using the now-discontinued du Pont Varigam paper with a No. 4 filter, rather than the normal No. 5 filter, I could get a good, low-range, slightly soft effect. The tonality of W. Eugene Smith's prints was an inspiration. Now I am interested in a "creamy" print. A "creamy" print is not necessarily lighter in tonality, although usually it is a step lighter. It is definitely softer in contrast.

I use Tri-X film with a developer called Harvey's 777, an old-time developer that I started with years ago. Gene Smith used it, and so did Cartier-Bresson in his early days.

It is a true fine-grain developer, and, to my way of thinking, wonderful. With Kodak D-76, for example, the grains form in clumps, and between the clumps there is clear space, which shows as black in the final print. Microdol-X dissolves the edges of the clumps to make them smaller. This creates more clear space between clumps of grain, which lends a darker overall cast to the print. This is how I understand it. With 777, there are more clumps but they are smaller, with less space between them. This makes a "creamier" print with a long tonal range.

Harvey's 777 is a panthermic developer, which means you can use it at any temperature, and it won't shift. It was designed for use in the tropics. It holds specular highlights and gives good contrast in the shadow areas. If you are photographing in a standard back-lit situation, you can go right into the shadows, produce a full tonal range, and yet still print through the sky.

What 777 is not, is a high-speed developer. You've got to be careful about exposure, especially in available light. You can't underexpose, and you can't "push" at all. But, then, I usually don't push my film anyway. I use 777 to specification, which gives me a slightly overdeveloped negative, because I use plastic tanks. The plastic tanks contain a higher volume of developer per roll, which means the chemicals don't exhaust as fast as they do in metal tanks. Furthermore, because of the design of plastic tanks, I don't have agitation problems. This is partly because the extra air space in the top part of a plastic tank creates a very active yet even bubbling kind of agitation. Also, the film reels in plastic tanks are held stationary by a center core. The developer goes through the reels more evenly and agitation is more uniform.

Harvey's 777 developer is shipped to me from Best Photo Industries, Inc., 2318 Watterson Trail, Louisville, Ky. 40299. I have to buy large quantities of it, so I go in with a few other "old-timers" who know about it.

Although I prefer 777 developer and Tri-X film, I've gotten good results with many different developers and films. I used to do exhaustive tests of film-developer combinations. I haven't done that for a while, but I am beginning to feel that I ought to, because Tri-X seems to change from time to time. My feeling is that it is getting sharper with a finer grain. I rate it from 320 to 400 ASA.

I do things pretty much by the book because I am a photojournalist. Perhaps I shoot an assignment a thousand miles from where the negatives are going to be processed. Tri-X at 400 ASA developed in D-76 is really the standard all over the world, so you know you won't have a problem no matter which lab processes it. If you depart from the standard, you can create problems for yourself.

The 35mm photographer must strive for the mean in exposure and film development, and then worry about varying contrast and so on in printing. My feeling is that the Zone System, which involves manipulating variables of exposure-development-printing, is terrific, but only if you are developing one sheet of film at a time and have a computer brain and lots of time.

In Hollywood, where the photographers expose millions of miles of 35mm film worth millions of dollars, incident light meters are used. The photographers there know what they're doing, so I use an incident meter too. Its quick average reading allows me to shoot spontaneously, without having to consider how different surfaces reflect light.

In the photograph GREENWICH VILLAGE (Figure 12) I had to expose for an extraordinary contrast range. The street was back-lit, and there were glaring fluorescent lights and lots of white Formica and stainless steel. I wanted to keep that glowing quality as well as the feeling of subtle details in the shadowy street.

When I photographed the scene, I took an incident

reading from where I was standing in the dawn shadows. Therefore, the reading did not take into account the interior light, the light on the White Tower or in the sky. Basically, I considered the street. I underexposed a stop so the street would be darker, but still give me some detail. If I had exposed for any other area of the picture, I would have lost the street. I used f/4 at 1/30 with a 21mm lens.

After selecting the negative (Figure 1), I consider what exposure to give the street in the print. The street doesn't have too much contrast, and so for my test strip, I choose a No. 4 Polycontrast filter. The filters I use on Polycontrast paper are numbered 0, 1, 2, 3 and 4. It is also possible to purchase filters in half-steps. To me, the advantage of the filter system is that it allows me to achieve variations in contrast within the same print.

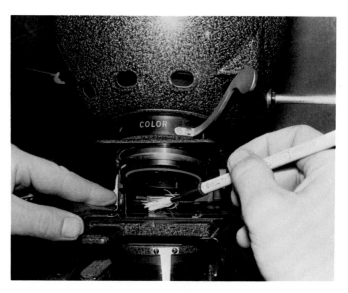

Figure 2.

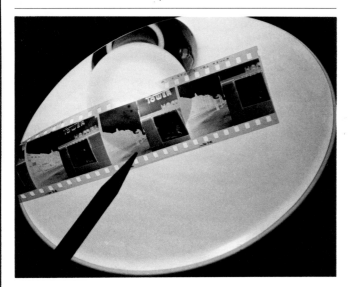

Figure 1.

I often use the brush on a typewriter eraser to clean dust off the base layer of the negative (Figure 2). A camel's hair brush frequently draws more dust than it removes, because it increases static electricity. A stiffer brush flicks off the dust. A grounded enlarger also helps to cut down on the static electricity problem.

After placing the Polycontrast No. 4 filter in the tray above the lens (Figure 3), I print in increments of 2 seconds at f/5.6, for test strip No. 1. That is, 2, 4, 6, and 8 seconds in the shadow area (Figure 4). The way I read a test strip is to look for the first point at which I achieve a black, before checking the other tones. That is 6 seconds in this test. But I notice that the street looks richer around 8 seconds.

I decide to work in increments of 3 seconds for test strip No. 2 (Figure 5). I give 6 seconds overall, then an additional exposure of 3 seconds in the street and sidewalk, while dodging the buildings in the background.

Figure 3.

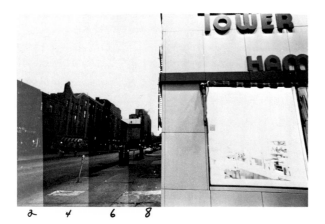

Figure 4.

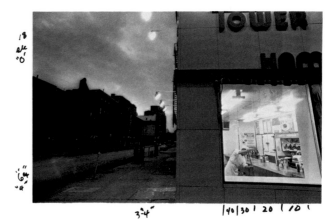

Figure 6.

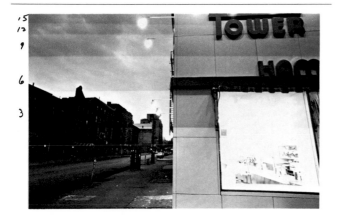

Figure 5.

I work with the sky on the test strip, and here is where the value of the filter system can best be seen. I switch to a Polycontrast No. 0 filter, the softest one, so the problems of burning in the edges of the sky are not so great. There are no black overlap lines. Now the sky gets 3, 6, 9, 12, and 15 seconds on the No. 0 filter. It is clear that 15 is best, and, in fact, the sky could probably use more exposure.

Meanwhile, I am also thinking about burning in more on the White Tower, because the upper portion is so close to the fluorescent lights that I am getting a "hot" spot. I also notice that the lower right-hand edge is starting to go dark, so I will have to dodge it.

I move to test strip No. 3 (Figure 6), the purpose of which is to work with the interior of the White Tower. I still haven't seen the man inside. I do my 6 second exposure overall with a No. 4 filter. Then I give 3 seconds more to the street and the White Tower. Now with the No. 0 filter, I give 18 seconds in the sky and on the White Tower.

At this point, the interior of the hamburger stand has received 9 seconds of exposure with a No. 4 and 18 with a No. 0. Now, I begin 10-second increments with a No. 0

filter; 10 seconds, 20, 30, 40. I almost choose to go to a more contrasty filter than a No. 0 for this area so the print won't become gray, but I decide on the No. 0 after all. I like the glow of the fluorescent lights at 30 seconds, rather than 40. I am not in as much trouble as I had thought with the White Tower, but I must make sure not to let the exterior of the building go dark.

So, now, the final print.

I place a sheet of old photo paper on the easel, and project the outline of the negative onto the back of the paper. Then I trace a mask (Figures 7 and 8), and make cutouts for the sky and the interior of the White Tower.

I carry out the decisions I have already made in my test strips regarding filters, number of seconds, and burning in. I also decide to burn in for 6 additional seconds with the No. 0 filter in the area of the Tower, to finish off the print and give it some tone.

Figure 7.

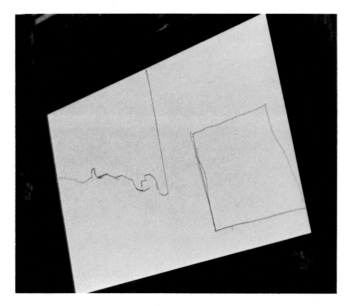

**Figure 8.**

When I am figuring out the number of seconds to give a print, I like to think in terms of modules or "hits," as I call them. It makes it easier to keep track of what I'm doing, and it means less changing of the timer. For example, on this print my basic module, or exposure increment, is 3 seconds. This is the reason that I chose to burn in the interior of the hamburger stand for 30 seconds, rather than 40. If I had wanted more than 30 seconds, I would have gone to 36, a multiple of 3, rather than to 40.

To summarize, my thinking process goes like this. I set the timer at 6 seconds. Okay, 1 hit of 6 seconds overall on filter No. 4. Then a half hit to the street, but counting seconds, 1 hippopotamus, 2 hippopotamus, 3 hippopotamus. Stop. Change filters. Mask around sky. Now 3 hits of 6 seconds each with a No. 0 for the sky. Mask around window. Now 5 hits of 6 seconds for interior and Tower. Then 1 hit with the No. 0 to Tower.

Let's suppose that I'm printing a negative that's too soft with a Polycontrast No. 2 filter, and too contrasty with a No. 3. I can create a No. 2½ contrast with the double-filter printing system. In this case, the best way to start is to assume that a No. 2 filter is equal to 5 hits of 1 second each on a No. 0 filter and 5 hits on a No. 4. A No. 3 filter would then be equal to 3 hits of a No. 0, and 7 hits of a No. 4. I create the No. 2½ filter with 4 hits of a No. 0 and 6 hits of a No. 4. I can also make a No. 2¼, No. 2¾, etc.

Basically, I think in terms of 10 hits, or exposure units, and I divide the number of hits between the two filters.

The possibilities for burning and dodging on different filters are limitless. While I'm making test strips, I may decide that a basic exposure for a normal negative is 10 seconds with a No. 2 filter. However, I see that the shadows are too dark. If I dodge the shadows while using a No. 2 filter for 10 seconds, the dark areas get lighter, but they also look dull. The solution is to start with an overall exposure of 5 seconds on a No. 4, to give contrast. Then I change to a No. 0, which gives tone rather than contrast, and I dodge the shadows during another overall exposure of 5 seconds. Both the highlights and shadows have contrast and tone, but the shadow area is lighter, with good separation of detail because, in effect, it has No. 4 contrast.

When I print, I use an ordinary florist's wire with a cardboard cutout at the end as my dodging tool because it is both thin and rigid. Sometimes I bend it out of its straight shape, downward at an oblique angle, to reduce the danger of a noticeable outline on the final print (Figure 9).

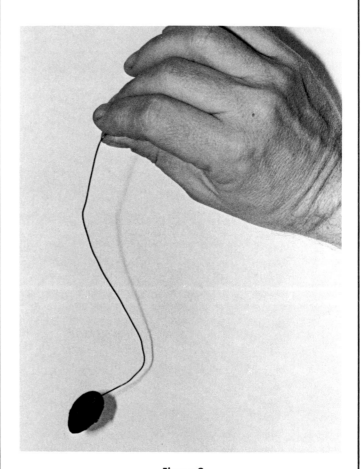

**Figure 9.**

For burning in, I cut holes of varying sizes in a sheet of black cardboard. I tape a cardboard flap over each hole, to cover it when I don't need it during exposure, and paint a white square around the hole to help me locate the proper area of the negative for burning in (Figure 10).

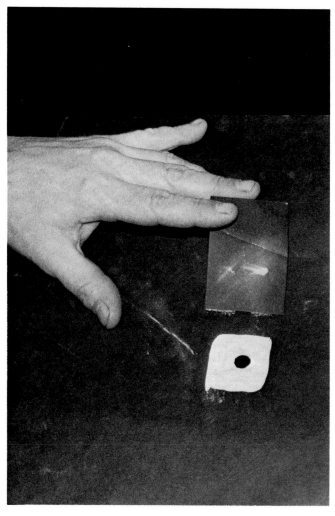

**Figure 10.**

The acetate filters come with tabs on the sides. To fit them into the filter tray on my Focomat, I have to remove the tab. I use a razor to score both sides of a filter. Then I break off the tab with pliers, and replace it with a little piece of tape with the filter number on it (Figure 11).

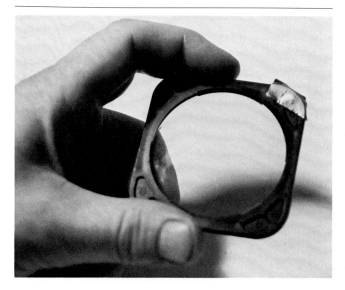

**Figure 11.**

In multiple filter printing, it's very important to bear in mind that there is a difference in the way gelatin filters and acetate filters treat light. The dyes in acetate filters are distributed so that light rays are distorted as they pass through the filter. So if you change acetate filters underneath the lens, you can get grain shift in the print, as if you had jiggled the enlarger. The dyes in gelatin filters are distributed so that light rays are not distorted. For this reason, gelatin filters can be put in a holder directly underneath the lens without affecting the sharpness of the image on the paper.

However, filters become dusty and get fingerprints and scratches. If a smudged or scratched filter is placed underneath the lens, it can cause distortion on the print.

The solution is to put filters in a tray <u>above</u> the lens. My Focomat enlarger has a filter tray, and so do all color head enlargers. I use the acetate filters in the tray because they're cheaper than gelatin.

In addition to Polycontrast filters, I have two Color Compensating (CC) filters: a CC30Y and a Wratten 85. With variable contrast paper, it is the ratio of yellow to bluish-red in the filters that modifies the contrast of the print (yellow for low contrast, blue for high). A CC30Y filter, in my opinion, provides even less contrast than a No. 0 filter. At times I want a contrast level somewhere between a No. 4 filter and a No. 4 grade of paper: there is actually a big jump. A Wratten 85 filter splits the difference. Its drawback is that it requires an extremely long exposure, but it's nice to know the filter is there when I need it.

I used another technique in my print of the vines at FONTAINEBLEAU (Figure 13). The print has the quality of a slightly smudged charcoal drawing. I got this effect by giving the unexposed paper a hit of .3 second of unfiltered light before putting in the negative and giving it the regular exposure with a filter. The flashing lowered the contrast slightly, and added tone in the highlights. I brought up the highlights on some of the vines and plants by bleaching with ferricyanide.

Infrared presents contrast problems in printing, but it is worth the extra effort in the darkroom. I started using infrared in situations where there is very little available light and people are moving. It's not that I mind the blurred motion resulting from slow shutter speeds at night. But I <u>do</u> mind camera shake, and sometimes I want to stop fast action. Flash is one solution, but it enables me to get only

one shot before it destroys the scene.

For me, the best approach is to load the camera with infrared film in total darkness, and then to cover the strobe with a Wratten 87 filter. It's possible to buy an infrared strobe unit, but I like the idea of making my own. The Wratten 87 is a standard 3" Kodak filter that fits most small conventional flash units today, or it can be cut to fit. The subjects don't even see the light. My experience is that the sensors in the light meters of most automatic flash guns read right through the filter.

Kodak recommends changing the focus slightly with infrared because of the longer wave-length of the light rays. But I don't take that factor into account; I just shoot, and then develop the film normally, relying on depth of field to make changing focus unnecessary.

The infrared image is very soft, which bothers some photographers. But to me it's not a problem because I like the rather romantic "glow," especially with subjects that aren't considered romantic as in NEW YORK, 1976, (Figure 14). I have to go to No. 4 or No. 5 paper for these negatives.

Currently I've been using the Sprint chemical system, with print developer, stop, hypo, and hypo eliminator. The chemicals can be purchased from Sprint Systems of Photography, Inc., 100 Dexter St., Pawtucket, RI 02860.

The system is worked out so that everything is in a 1:9 relationship, and the number of things you have to think about is reduced. I just have to run down the line: 200cc to 1800cc for all the solutions. I can just walk into the darkroom, throw the switch, and be ready to go in minutes.

Sometimes I add a restrainer to my paper developer. Most of the time I use Edwal's Orthazite, but it seems hard to get right now. So I am using potassium bromide in a 1:10 solution. I add 1 oz. of the bromide to 10 oz. water. It is an antifogging agent, and it slows the developer's speed and holds the whites.

Another good thing about potassium bromide, or any restrainer, is that I can leave a print in the tray for 4 or 5 minutes, rather than the recommended 90 seconds for Sprint developer. I like this because I find that sometimes the shorter recommended development time does not deal with delicate differences between whites and light grays. With the restrainer, I can get a little more tonality in the high range, a better separation between the ultimate white and a pale light gray.

This also means I don't have to burn in as much. In fact, a curious thing has happened to me over the years. I remember when I first started that I had to do a lot of burning and dodging and even ferricyaniding. Now it seems all those things are less required; prints seem to come easier.

I also add an energizer to produce a really good rich black. The stock solution consists of 2 oz. sodium carbonate to 32 oz. water. I add 3 oz. stock solution per quart of developer. The energizer gives me slightly more contrast. This is desirable, because I find that these days I am using a No. 4 filter on prints that I used to make with a No. 3. Unless I have changed my technique, something has been changed in the amount of silver in the paper.

When I am working in the darkroom, I try to make 10 finished prints from each negative that is important to me. I give a signed print to each of my three children.

I have salvaged prints under nearly impossible circumstances. Once I made prints from negatives I had forgotten to agitate during development. Just as I started developing, the trap fell out of the drain in the sink and the water gushed all over the floor. I'd just about gotten it back together when the buzzer went off. Frantic, I put the film in the hypo and just as the reels sank to the bottom I realized I hadn't agitated the negatives. They came out very thin, but Brovira No. 6 and a lot of careful ferricyaniding, burning and dodging yielded prints. I wanted the pictures, and so I stayed with them in spite of everything that went wrong. Printing has more to do with determination than magic.

There was one time when the automatic diaphragm on a borrowed camera failed me, and I found myself with a roll of negatives shot at 1/500 at f/2 instead of f/16. There was nothing to do with the negatives but turn on the enlarger, light up a cigarette, listen to music, and wait.

The GREAT BARRINGTON carnival shot (Figure 15) also required a long exposure. It was overexposed on purpose, however. The reading was for the little man in the tent, which threw all the rest of the shot 4 or 5 stops over.

I shot a lot of other pictures of the carnival sign that day, all with pretty obvious juxtapositions of people in the foreground. All properly exposed, all dull. I don't even remember shooting this one. You don't always know what the good pictures are going to be when you shoot them; they emerge later in the darkroom.

When I walk out of the house, I have a couple of Leicas over my shoulder, and a bag with an extra lens or two. Most of my photographs are made in available light, with either a 35 or 28mm lens. A 50mm is my "telephoto." One reason I use wide-angle lenses is that I am very nearsighted, even with my glasses, and a 35 or 28mm puts everything into focus without my having to worry about it. For me, it is spectacular to have everything sharp from foreground to background. It creates the effect of fantasy.

But then, all of my photographs are about fantasy.

| FILM | ASA RATING | DEVELOPER | SOLUTION & TIME | AGITATION |
|---|---|---|---|---|
| Tri-X <br> HP 5 | 400 | Harvey's 777 | Undiluted <br> 68 F <br> 12 minutes | Continuous for first minute, then 10 seconds in each minute in plastic tank <br> For metal tank, load only bottom 4 rolls on 8-roll tank; roll tank on side |

| ENLARGER | LENS | LIGHT SOURCE | USUAL APERTURE | USUAL EXPOSURE |
|---|---|---|---|---|
| Focomat 1C with color head | Focotar 50mm f/4.5 (for prints under 11x14) <br> Schneider Componon 50mm f/4.5 (for prints over 11x14) | 212 | f/5.6 | Determined by test strips |

| PAPER | DEVELOPER | SOLUTION & TIME | STOP BATH | FIXER |
|---|---|---|---|---|
| Kodak Polycontrast F | Sprint Quicksilver <br> Dektol | 1:9 1½ to 2 minutes <br> 1:1 3 minutes <br> 68 F | Sprint Block Stop Bath 1:9 10 seconds | Sprint Record Speed Fixer 1:9 <br> 2 baths bath 1: 2 minutes with hardener (hold in tray wash) bath 2: 2 minutes without hardener to facilitate spotting |

| WASH | TONING | DRYING | FLATTENING | PRESENTATION |
|---|---|---|---|---|
| 45 Minutes to 1 hour in East Street Gallery Washer | Selenium <br> 1 gal. Perma Wash solution or Sprint Archive 1:9, 2½ oz. Kodalk Balanced Alkali, 7 oz. selenium <br> 3 to 4 minutes | Fiberglas screens with hot air (Watson Duo Dryer) <br> 45 minutes | Sandwiched between archivally processed photo paper or rag board in drymount press <br> 180 F <br> 10 seconds | Undrymounted <br> 100% pure rag overmattes with archival corners |

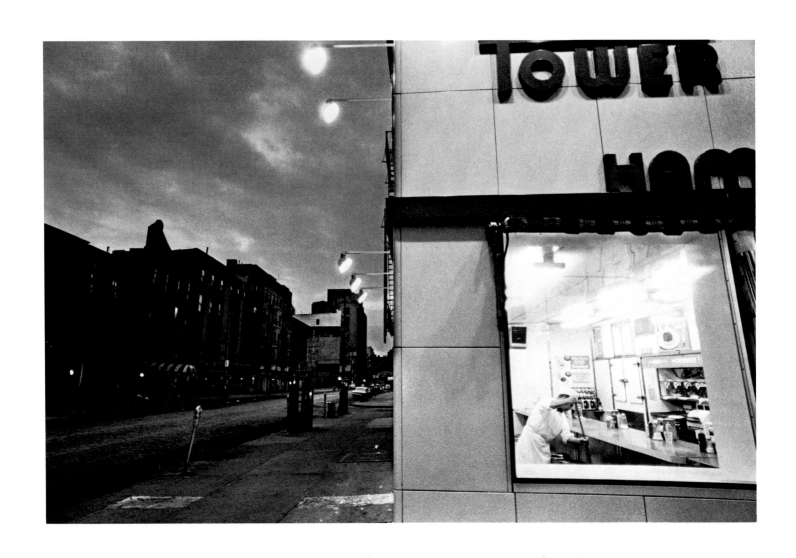

**Figure 12: GREENWICH VILLAGE, NEW YORK, 1960**

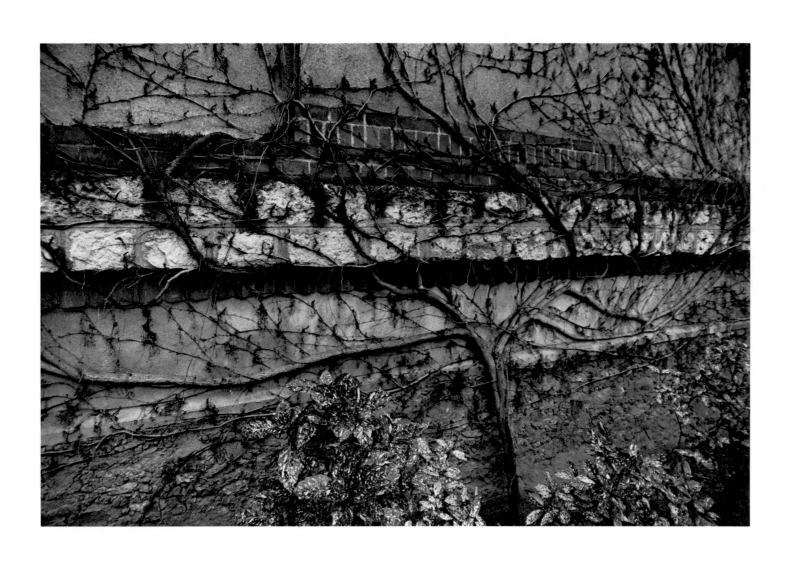

**Figure 13: FONTAINEBLEAU, 1978**

Figure 14: NEW YORK, 1976

**Figure 15: GREAT BARRINGTON, MASS. 1977**

# LISETTE MODEL

Lisette Model was born in Vienna, Austria. She studied music with Arnold Schoenberg in Vienna. After her father's death, her French mother returned to France and Model accompanied her to continue her study of music in Paris. In 1937 she began to paint and photograph.

She came to New York with her painter-husband, Evsa Model, in 1938. Within a few years she was under contract to HARPER'S BAZAAR, and she continued photographing for the magazine for about ten years. Model free-lanced for magazines, including LOOK, LADIES' HOME JOURNAL, etc.

From 1951 to the present, she has taught at the New School for Social Research in New York. In addition, she has given workshops in photography all over the country.

Selected shows:
Museum of Modern Art, New York, N.Y.
International Museum of Photography at
George Eastman House, Rochester, N.Y.
Art Institute of Chicago, Chicago, Ill.
Museum of the Legion of Honor, San Francisco, Calif.
Focus Gallery, San Francisco, Calif.
Sander Gallery, Washington, D.C.

Selected collections:
Museum of Modern Art, New York, N.Y.
Smithsonian Institution, Washington, D.C.
New Orleans Museum of Art, New Orleans, La.
International Museum of Photography at
George Eastman House, Rochester, N.Y.

The way in which I came to photography was an accident. I met a well-known composer in a cafe in Paris in 1937. He asked me what I was doing, and I told him that in addition to being a musician, I was starting to paint. "I have just fled Germany, and the whole world is going to burn," he said. "Your family's estates in Italy will be destroyed, and you will have no way of earning a living."

I knew that a war was coming, but it was a shock to think of how it would affect my life. Over and over I said to myself, "What am I going to do?"

It so happened that my sister was an excellent amateur photographer. This made me think, "I'm going to earn my living by being a darkroom worker."

I was interested only in finding a way to make money, not in photography itself. Whenever I saw photographs I thought, "What are these horrible black and white and gray things I cannot relate to?"

I bought equipment, including a Rolleiflex and an enlarger. I bought the camera because I would have to have negatives in order to practice developing and printing.

Once I had the camera, I didn't know what to do with it. My sister didn't want to take the time to show me anything. But then I met a woman, a painter, who had just started to work with a camera to make a living. I asked her if she would show me how to use the Rolleiflex. She said she had never worked with one, but she would try.

When we went out to take pictures, she said, "What do you see?" I said, "I don't see anything."

"What do you want to photograph?"

I had no idea.

"Never photograph anything you are not passionately interested in. Do you see this woman over there?" Yes, I saw the woman. And I looked further, and saw another picture and another. This was a lesson and the beginning

I went to my mother's house in Nice and continued photographing while I taught myself how to develop and print. People saw my photographs, and they were shocked, and they laughed, and they asked, "Where did you find this picture?"

I replied, "Right over there." Suddenly they discovered the people in these pictures too.

For all of these pictures, I used the Rolleiflex because it was all I had. One camera and one lens. It's the best thing that can happen to any photographer. What I liked, and still like, about the Rolleiflex is the relatively large size of the 2¼ negative and the low viewing angle of the camera. But I do not like the square shape of the frame.

Why should the photographer conform to two or three commercial proportions, like the square format of the 2¼ negative, or the elongated, too narrow shape of the 35mm negative? Many photographers have the sacrosanct attitude that one must use the entire negative, and that

cropping it is a sign of failure. Photography should not be compared to painting, but there is no painter who paints only in the same shape.

One should be free to select one's own format. I have suggested to camera designers that they invent a device to put in the camera to enable the photographer to decide upon the format of the negative before the picture is taken.

In the ground glass I see several possibilities within the frame. This was the case with the CIRCUS MAN, done in Nice in 1937. The man was just sitting on the bench and I photographed him from both the front and back. Later I discarded the front view because it was weaker. The power of the man's body shows from the back.

I took the picture in strong sunlight. However, I wanted to isolate the circus man from his surroundings, and so I blurred the background by opening up the lens to f/3.5. Of course, the negative was extremely overexposed, but at the time I didn't know that would happen. When I printed the picture of the CIRCUS MAN, I saw that the full-negative version was more or less an illustration or a documentation (Figure 2). Because I cropped the negative the way I did, the image is simplified and intensified (Figure 3).

After this summer in Nice, I returned to Paris and continued photographing. Then, in 1938, I came to New York with my painter-husband, realizing that soon I would have to make a living.

I read an ad for a darkroom worker for the newspaper PM, and took my photographs to the art director. The next morning he called me and I went over to his studio. He asked me what I wanted to do.

I said, "I want to be a darkroom worker."

"You must be crazy," he said. "You are one of the great photographers." And then he published nine pages of my photographs in PM. Overnight, I was "famous." A terrible danger for a beginner. And not only for a beginner.

He also took my pictures to HARPER'S BAZAAR and showed them to Alexey Brodovitch. My photographs were such a contradiction to the elegance of the magazine that Brodovitch, the extravagant art director, put them in for that reason alone.

The editor I worked with most at HARPER'S BAZAAR was Dorothy Wheelock, who was most adventurous. One day in 1950 she suggested I go to the Flea Circus on 42nd Street to see what I could find.

I did not photograph the freaks. But there was a man there who fascinated me. He claimed to be a Parisian who had been a woman up to the age of 35. After the birth of her third child, slowly she changed into a man. He had charm and sex appeal, and was a great performer.

The difficulty in printing the negative is that part of it is overexposed and part of it is underexposed. This "problem" is actually an advantage because the high contrast

makes the picture more theatrical.

In the first version of the HERMAPHRODITE picture, one sees the room, the flowers, and the lamp. Again, as with the photograph of the CIRCUS MAN, the first version gives an overall impression (Figure 4). Both versions are valid, but the second is stripped to the essentials (Figure 5).

When I take pictures, I go very close, but I can't always get that close. In this instance, there were seats in the way, and the hermaphrodite was on a stage. If I had simply gone closer, there would have been distortion. The perspective would have changed. So the problem had to be resolved in the enlarger, through cropping.

It was the enlarger that was my teacher (Figure 1). This is where I started to understand the difference between what the eyes see and what the image is. The translation of three-dimensions onto a two-dimensional surface (where the third dimension becomes an illusion) has always been a great problem for the image maker.

**Figure 1.**

When I first came to New York, I was fascinated by skyscrapers and wanted to photograph them. But in the ground glass, from the street level, the lines of the buildings shortened and converged. The distortion was discouraging. Tired of looking up, suddenly I pointed my camera downward, feeling that something must be going on there. One leg passed in front of the camera and I pressed the button. And then another leg came, and then two, and then many, and I made my photograph (Figure 6, RUNNING LEGS).

**Miniature printing frame**

**Print in hypo**

This I did for six weeks, and never again.

One day I wanted to photograph Fifth Avenue to send as a post card to my sister in Nice, to show her how small Fifth Avenue was in comparison to the boulevards of Paris. I wanted to take a straight photograph of the Avenue, but I couldn't find the angle, and I gave up. I turned my head and accidentally looked into a store window and there it was: Fifth Avenue as a natural photomontage (Figure 7, REFLECTIONS). One could see the objects in the window, the people passing by in front of the window, the reflection of the traffic in the middle of the Avenue, and the reflection of the people and buildings on the other side of the street. With each angle, another vision.

The magic of this imagery was not the only thing that fascinated me. Inside the window was glamour, fashion, Hollywood, luxury. On the outside was traffic, movement, speed. The pace, the tempo, the economy of the city were reflected in these windows. Photographing reflections in windows became a never-ending passion.

I wanted to photograph skyscrapers, and wound up with running legs. I wanted to make a straight photograph of Fifth Avenue, and discovered reflections in windows.

**View of darkroom**

69.

Are these really accidents?

When I made the REFLECTIONS photograph, I had a choice of focusing on the first plane, the middle plane or infinity. This picture is focused on infinity, but I also have other pictures in which I focus on the first or second planes.

When I first saw photographs in this country, it struck me that they were all in focus from foreground to background. Nothing I did was completely sharp on all planes. From the beginning, I was fascinated by the potential for variation of sharpness and unsharpness with the camera. I played with this ability in the RUNNING LEGS and REFLECTIONS pictures.

I have often been asked what I want to prove with these and other photographs. The answer is: I don't want to prove anything. The camera is an instrument of detection. We photograph not only what we know, but also what we don't know. When I point the camera at a subject, I am asking a question. Sometimes the photograph is the answer; I am the one who gets the lesson.

| FILM | ASA RATING | DEVELOPER | SOLUTION & TIME | AGITATION |
| --- | --- | --- | --- | --- |
| HP5 <br> ___ <br> Tri-X <br> Recording film | Varies, but usually 400 <br> ___ <br> 400 | FG7 <br> ___ <br> D-76 | Undiluted, mixed with sodium sulfite <br> 5 to 7 minutes <br> Undiluted <br> 8 minutes | Continuous for the first 30 seconds, then 5 seconds out of every 30 seconds |

| ENLARGER | LENS | LIGHT SOURCE | USUAL APERTURE | USUAL EXPOSURE |
| --- | --- | --- | --- | --- |
| Leitz | 50mm for 35mm negatives <br> ___ <br> 80mm for 2¼ negatives | 211 | f/5.6 or f/8 | Varies |

| PAPER | DEVELOPER | SOLUTION & TIME | STOP BATH | FIXER |
| --- | --- | --- | --- | --- |
| Agfa Brovira | Dektol and others | 1:2 <br> ___ <br> Varies, 1½ to 4 minutes | 28% acetic acid solution <br> 30 seconds | Kodak Rapid Fix <br> ___ <br> 2 baths <br> 5 minutes each |

| WASH | TONING | DRYING | FLATTENING | PRESENTATION |
| --- | --- | --- | --- | --- |
| 2 hours | Selenium in Perma Wash solution | Air dried | Under weights | Undrymounted |

**Figure 2: CIRCUS MAN, 1937 Uncropped version**

**Figure 3: CIRCUS MAN, 1937 Cropped version**

**Figure 4: HERMAPHRODITE, ca. 1950 Uncropped version**

**Figure 5: HERMAPHRODITE, ca. 1950 Cropped version**

Figure 6: RUNNING LEGS, ca. 1945

**Figure 7: REFLECTIONS, ca. 1948**

77.

# HANS NAMUTH

Hans Namuth was born in Essen, Germany, in 1915. He left Germany when he was 18, and became a free-lance photographer based in Paris.

In 1936-37 he photographed the Spanish Civil War for VU and other magazines. During World War II he served first in the French Foreign Legion, then in the Military Intelligence Service of the U. S. Army, becoming a U. S. citizen in 1943.

After the war, he went back to photography, and studied at the New School for Social Research in New York with Josef Breitenbach and Alexey Brodovitch. Namuth's work appeared in many magazines, including LIFE, LOOK, FORTUNE, HARPER'S BAZAAR, HOLIDAY, and VOGUE.

Namuth's portraits of artists have gained wide recognition. Many of them were published in 52 ARTISTS (New York State Council on the Arts, New York, 1973).

In addition to doing still portraits of artists, Namuth collaborated with Paul Falkenberg in the making of films on Pollock, de Kooning, Albers, Brancusi, Matisse, the architect Louis I. Kahn, and others.

Selected one-man shows:
1949: American Museum of Natural History, New York, N.Y.
1950: Pan-American Union, Washington, D. C.
1958: U. S. Pavilion, World's Fair, Brussels, Belgium
1967: Museum of Modern Art, New York, N.Y.
1973: Leo Castelli Gallery, New York, N.Y.
1974: Corcoran Gallery of Art, Washington, D. C.
1975: Leo Castelli Gallery, New York, N.Y.
1976: Broxton Gallery, Los Angeles, Calif.
1977: Leo Castelli Gallery, New York, N.Y.
1978: Saint Peter's Church, New York, N.Y.

Selected collections:
Metropolitan Museum of Art, New York, N.Y.
Museum of Modern Art, New York, N. Y.
Cleveland Art Museum, Cleveland, Ohio
Virginia Museum of Fine Arts, Richmond, Va.
Tulane University, New Orleans, La.

PETER NAMUTH

Let the pictures talk.

As Lewis Hine said, "If I could tell the story in words, I wouldn't need to lug a camera."

What comes first for the photographer is: I must, I will take this picture. And, as the problems are singled out: Can I? How? With what?

I grew up with the Leica and the Rolleiflex. They were with me when I photographed the Spanish Civil War. My companion, Georg Reisner, carried one format camera and I, the other, and from time to time we switched around. No light meter. Later, I began to use the 4x5 Linhof, the Weston light meter, and finally, the 8x10 Deardorff. The Deardorff became a passion. I wouldn't use anything else. Slowly I found my way back to 35mm, prompted by the photographer and filmmaker Herbert Loebel. Today I use all sizes, as the spirit moves me or the job at hand demands.

For years much of my favorite work has consisted of portraits. A portrait can be a snapshot, or a formal sitting requiring hours, days, or sometimes years, to arrange. Ideally, it reflects the one moment in which the subject's personality is revealed most completely.

I have made many portraits of artists, like Jackson Pollock (Figure13), whom I photographed and filmed numerous times. At the time of his death, I spent a long time with him as he lay in a funeral parlor. As I looked at him I had the urge to photograph him. He was extraordinarily beautiful. The torment had gone from his face. It would have been my ultimate portrait of him. The undertaker wouldn't allow it.

When it became a matter of utmost importance for me to photograph another great artist, Joseph Cornell, I didn't know what to do. He was to be included in the book AMERICAN MASTERS: THE VOICE AND THE MYTH, by Brian O'Doherty (Random House, 1973). Cornell was a recluse who loathed photographers. Someone from LIFE Magazine, as he explained to me later, had played him a dirty trick. One day Cornell called to tell me that he wasn't ready to see me yet, to be patient. He wrote several notes to me, some with pictures of flowers glued onto them.

It was difficult for him to live alone after his brother and his mother had died. His calls came unexpectedly, in the middle of the day or late at night. Whenever they came, I brushed everything aside and made the time to talk to him. Sometimes our talks lasted half an hour or more. Slowly he gained confidence. I promised never to publish any picture he did not approve, a promise I have kept.

When our first appointment was finally arranged, I was full of anxiety and I urged a friend to come. Later I started to take pretty women with me. Cornell loved women, in total innocence and wonder. I was delighted to learn that he had collected a number of my pictures. One was of the artist Lee Bontecou, whom he adored.

From the time I had contacted him, a year went by before I could finally raise my camera, nervous as a beginner, to take my first picture of Joseph Cornell. Thereafter I photographed him on a number of occasions.

From time to time, I took him in my car to Westhampton, Long Island, to visit one of his two sisters. One day, we found the house door locked. While waiting for his sister's return, we went to the beach. He was impatient. The drive from the city had worn him out. That day, one year before he died, I photographed him for the last time (Figure 14).

My awareness of photography began in my childhood. I grew up in Essen, Germany, which most people associate with the Krupp Steel Works, and a few, with the photographer Albert Renger-Patzsch. As a child, I passed Renger-Patzsch's studio often. It was no different from any other small town photographer's studio. It was on the street level, with a storefront window that had many pictures on display. Only much later did I come to realize what an extraordinary photographer worked behind that window.

A hundred miles from there, in the same province of Rhineland, lived August Sander. I was 13 when Sander took a picture of the architect Hans Lüttgen, with his first wife Dora, in the city of Cologne where they lived (Figure 15). In 1975, Hans Lüttgen came to see me in New York, and asked me to take a photograph for a forthcoming show of his paintings at the Goethe House in New York. He introduced me to his second wife Renée, and I was struck by her resemblance to the woman in August Sander's picture. One day, in his studio, I carefully posed Hans and Renée exactly as August Sander had posed the architect and his first wife in 1928 (Figure 16). The portrait was to become part of a study of people living together.

In 1947 I began to take great interest in the Mam Indians of the village of Todos Santos, in the Guatemalan province of Huehuetenango. My wife and I made our way to the small village in the Cuchumatanes mountains on muleback. We went to the house of Maud Oakes, an American who lived there in order to study the religious practices of the Mam Indians. Her book, THE TWO CROSSES OF TODOS SANTOS (Princeton University Press for the Bollingen Foundation, 1950), was illustrated with her photographs, and a half a dozen of mine.

The village remained a haunting memory for me. In 1978, thirty-one years after my initial visit to Todos Santos, I returned to continue making portraits of the villagers. The soul of the Indians had remained the same, as had their dignity, beauty, and ties to nature and to their past.

I found a place to stay in the house of a family in the village. At first I would eat only the canned and packaged food I had brought with me, such as sardines and crackers. The second night I had food poisoning from a can of mackerel and became quite ill. I was up most of the night,

but I started my photographing promptly at 9 a.m., as scheduled. The appointments with the Indians had been so difficult to set up, and how could I disappoint them? After that experience, I ate the food the natives cooked for me, and found it delicious. I had no further trouble.

My equipment consisted of two Hasselblad bodies, a Polaroid back, and three Zeiss lenses. Most of the portraits were taken with a 100mm lens, and some with a 150mm or an 80mm. I took 30 rolls of Polaroid Type 32 film, 30 rolls of Tri-X, and 30 rolls of VPS film.

My studio consisted of 32 yards of unbleached muslin or "manta," pitched like a tent against the local church wall (Figures 1 and 2). This is the material the Guatemalan Indians use to put up their stands when they take their wares to market. My tent diffused the light beautifully, and also provided privacy. The wall of the church served as a backdrop, although occasionally I used a black cloth.

With the help of my Indian assistant, Victoriano, who translated my pidgin Spanish into Mam, I slowly gained the confidence of the villagers. The priest, Father Flaherty, a Maryknoll missionary, helped enormously by walking up and down the village with me and by introducing me to the mayor and other members of the governing body, even to some of his rivals, the shamans, or medicine men.

In a five-day period, I made 60 photographs of individuals, couples, and groups. Victoriano kept a notebook in which he placed each person's name, age, and profession. Every adult received a Polaroid photograph as a gift. Some requested enlargements, which I sent after I had processed and printed the film in New York.

Originally, I had intended to stay a week, but after five days I ran out of Polaroid. I decided to journey back to the capital, Guatemala City, to watch and perhaps record the Presidential election before going back to the United States. I look forward to returning again to Todos Santos to go on with my work.

When Alexey Brodovitch was my teacher at the New School for Social Research, he said, "You cannot be a photographer and work from 9 to 5, like a secretary or garage attendant. It's a 24-hour commitment or nothing."

After the shutter has been clicked, the picture is only half completed. The work in the darkroom is an integral part of making a photograph, and equally exciting. It is a sublime moment when the image emerges. Everything that went on beforehand reveals itself miraculously.

"Your print must gleam," Josef Breitenbach, another old teacher of mine at the New School, used to say. "Only then should you take it out of the developer."

Breitenbach was quite willing to share his technical knowledge with his students, but photographers have not always been so generous.

When Georg Reisner and I worked in Paris in the late

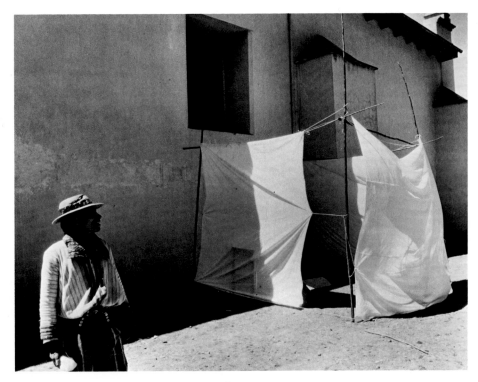

Figure 1.

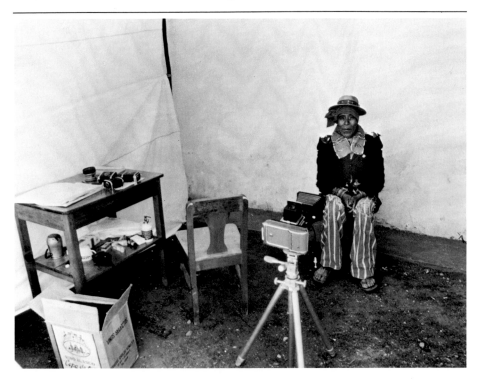

Figure 2.

30s, a wonderful photographer who used the name Re-lang came back from Portugal with perfectly beautiful pictures. As we looked admiringly at her prints, I asked her, innocently, "Tell me, what developer did you use for processing these negatives?"

"Sorry," she said, "it's a professional secret."

Soon afterward, however, by coincidence, we started using the same Agfa developer, now discontinued, called Atomal. We loved it. But, thank God, times have changed. There are no professional secrets anymore.

My friend David Attie first told me about the technique of point source illumination, which he had learned from Hiro. Primarily, it is used when high resolution is important, as in printing microfilm for biomedical or police purposes. I've been using it for many years.

I consider grain to be the soul of the negative. I like point source illumination because it makes the grain look extremely sharp on the print. It also increases contrast by about one grade of paper.

The point source enlarger is a variation of the condenser enlarger. It is constructed to eliminate as much diffusion of light rays as possible. Its light source is a very small, intensely focused, unfrosted bulb at the end of an adjustable tube. The light rays pass down without bouncing around beforehand in the condenser head. The circle of light created is narrower, the grain appears sharper, and the transition from light to dark at the edge of the shadow areas is more sudden.

My Omega D2 enlarger is equipped with a DM (point source) condenser lamphouse. For 35mm work, I use an 80mm enlarging lens; for 120 work, a 105mm lens; and for 4x5 work, a 135mm lens. The enlarging lens has a longer than normal focal length to refract a narrow cone of light. For each focal length enlarging lens, a corresponding DM condenser set must be used.

The enlarging lens must be left wide open during both adjusting and printing, or it will produce vignetting at the edges of the negative. Because f/stops cannot be changed in point source enlarging, the light intensity must be adjusted with a rheostat or transformer. I use a Nikon transformer designed for high-intensity microscope work. The calibrations are from 8 to 3, with 8 as the "hottest."

As I lower the calibration, I begin to lose contrast. This is because a transformer modifies the color of the light as well as its intensity. The color moves toward the yellow side of the spectrum, which produces a "softer" print. Changing from a calibration of 5 to 3 results in a reduction in contrast equal to about one full grade of paper.

Before beginning to print, I determine that the bulb is in the correct relationship to the negative and lens, ensuring the most even lighting across the paper. This is an extremely important step, and it is done by eye. First, I make sure there is not a "hot spot" of light at the center of the easel, nor vignetting at the edges (Figures 3 and 4). I then move the tube with its attached light bulb up and down until the illumination is uniform (Figures 5 and 6).

**Figure 3.**

**Figure 4.**

**Figure 5.**

**Figure 6.**

**Figure 7.**

I examine the negative for dust when it is placed in the carrier, under the enlarger light. If I can't get the dust off with compressed air, I use my fingers. They work well, but I must take care not to make scratches (Figure 7). Any dust, any scratch shows up dramatically in point source work.

Next I check for focus. I project the negative onto the back of a piece of old photographic paper, rather than the bare easel, to allow for the thickness of the paper. If I use only my eye, I may <u>think</u> the negative is in perfect focus, because point source has a wider range within which the image seems sharp. This is due to the construction of the negative in layers and to the way in which the light passes through it. Because point source light is not diffused, the layers of the negative are projected onto the paper separately, which creates an aerial effect. The photographer may accidentally bring the base layer into highest resolution rather than the emulsion.

It is essential to use a grain focuser to find the emulsion layer (Figure 8). As I focus on the grain, it is helpful to look at an area with both light and dark tones. This enables me to judge the sharpness of the individual grains in relation to acutance, or edge sharpness between adjacent tones.

**Figure 8.**

Now I'm ready to make exposure tests, for which I tear a sheet of paper into strips.

To print GROUP OF JUNIOR POLICE I start with Ilford Ilfobrom No. 1, a grade which is considered softer than normal, but which works well with point source. I make test strips with the transformer set at 4: two on grade No. 1 for 14 and 16 seconds (see Figures 9 and 10, respectively); and two on grade No. 2, for 14 and 20 seconds.

While working on test strips, I experiment with burning and dodging. The trouser legs of the men require some dodging, but their shirts and hats need burning in. I prefer to burn in with my hands.

**Figure 9.**

**Figure 10.**

After developing and clearing the test strips, I study them, bearing in mind that prints have a tendency to look darker after they dry (Figures 11 and 12). I also try to visualize how selenium toning will affect the blacks in the final print. I decide on an overall exposure of 14 seconds on No. 1 paper (Figure 17). I prefer an exposure time of about 30 seconds, which gives me time to work on the print.

**Figure 11.**

**Figure 12.**

My favorite paper developer is Edwal TST, diluted 1:7 (8 oz. Solution A; 1 oz. Solution B; 64 oz. water). Its advantage is an exceptionally long tray life. The exposed paper remains in the tray two minutes. I leave the paper face down for more than a minute to guard against fogging. To create a softer effect, I dilute the developer 1:15, or even 1:40, following the manufacturer's instructions for proportions.

Sometimes I use hot water on the tips of my fingers or on a cotton swab to accelerate development locally. This brings out the detail on the shirts and hats of the men.

I use my hands to transfer the paper from tray to tray. The developed print goes into the stop bath for 30 seconds, before being passed to the tray with Kodak Rapid Fix, where it remains for 5 minutes. I wash the print in running water for 10 minutes. Then I move it to the hypo eliminator, Perma Wash, for 10 minutes, and into another tray wash for at least 30 minutes more.

I let my prints dry down. Then I choose the ones I want to selenium tone, which contributes to the permanence of the print. The selected prints are put into fresh hypo 3-5 minutes, then into a toning solution.

The formula for toning consists of 1 gallon working solution of Perma Wash to which 2½ oz. Kodalk Balanced Alkali and 7 oz. selenium have been added. The Kodalk Balanced Alkali neutralizes hypo and prevents staining. I tone for approximately 5 minutes. Recently, I rediscovered prints I had selenium toned in 1947, and they had remained as beautiful as ever.

After toning, the prints are washed for 30-60 minutes, and air dried on Fiberglas screens (Figure 18).

The only film developer I use now for both 35mm and 120 work is Edwal's Minicol II. The average development time for Tri-X at 200 ASA (my favorite rating) is 16 minutes; at 400 ASA, 20 minutes. I use Minicol because it is a slow developer, which gives me time to inspect the negatives. When I shoot several rolls of film under uniform lighting conditions, I inspect a sample roll under a No. 3 green safelight. Minicol also has an interesting and very fine grain structure, which works well with point source.

If I push Tri-X to 800 ASA or above, I use Acufine, and develop according to the instructions.

At one time I was sold on an English film developer, Ergol, and when it became unavailable here, I imported it myself from England. The other day, I noticed that I still have several dozen packages of Ergol.

As a rule, I like simplifying things and saving time. I used to mix all of my chemicals (including, once, Edward Weston's formula for his paper developer), but no more.

I have forgotten a lot over the years, but I learn new things every day and, in turn, forget those, unless I pin up notes and formulas on the walls of my darkroom. To me, a photographer is like a pianist. He must practice his technique constantly, or he will lose it.

| FILM | ASA RATING | DEVELOPER | SOLUTION & TIME | AGITATION |
|---|---|---|---|---|
| Tri-X | 200 (preferred) 400 800 | Minicol II ___ 70 F | 1:7 9 minutes (by inspection) ___ 200 ASA: 16 minutes 400 ASA: 20 minutes | Continuous for 2 minutes then 7 times in 5 seconds out of every 30 seconds |

| ENLARGER | LENS | LIGHT SOURCE | USUAL APERTURE | USUAL EXPOSURE |
|---|---|---|---|---|
| Omega D2 chassis with DM lamphouse | Rodenstock-Omegaron 105mm f/4.5 ___ Schneider Componon 80mm f/5.6 ___ Wollensak 135mm f/4.5 | DM (point source) ___ 6 volts 18 watts | Wide open | 25 to 30 seconds with transformer calibration at 4 |

| PAPER | DEVELOPER | SOLUTION & TIME | STOP BATH | FIXER |
|---|---|---|---|---|
| Agfa Brovira ___ Ilford Ilfobrom | Edwal TST | Usually 1:7 (1 oz. Solution A, 8 oz. Solution B, 64 oz. water) ___ 2 minutes | 28% acetic acid solution ___ 30 seconds | Kodak Rapid Fix ___ 2 baths 5 minutes each |

| WASH | TONING | DRYING | FLATTENING | PRESENTATION |
|---|---|---|---|---|
| 10 minutes running water ___ 10 minutes Perma Wash solution ___ 30 to 60 minutes tray wash | Selenium ___ 1 gal. Perma Wash solution, 2½ oz. Kodalk Balanced Alkali, 7 oz. selenium ___ 5 minutes | Fiberglas screens | Sandwiched between photo papers in drymount press | Unmounted ___ 100% pure rag overmattes with archival corners |

**Figure 13: JACKSON POLLOCK, 1952**

**Figure 14: JOSEPH CORNELL, WESTHAMPTON, N.Y., 1971**

**Figure 15: HANS AND DORA LÜTTGEN, 1928, BY AUGUST SANDER**

**Figure 16: HOMAGE TO AUGUST SANDER, 1975**

**Figure 17: GROUP OF JUNIOR POLICE, TODOS SANTOS, 1978**

**Figure 18: GROUP OF JUNIOR POLICE, TODOS SANTOS, 1978 (Final version)**

# DOUG PRINCE

Doug Prince was born in Des Moines, Iowa, in 1943. He began the study of photography as a freshman at the University of Iowa, where he earned a BA in 1965 and an MFA in 1968.

For the next eight years, 1968-1976, he taught at the University of Florida as an assistant professor of photography. In 1972 he won Le Prix de la Ville D'Avignon.

Since 1976, Prince has been an assistant professor at the Rhode Island School of Design. He was awarded a National Endowment for the Arts grant in 1977.

Selected one-man shows:
1973: Light Gallery, New York, N. Y.
1974: University of Tennessee, Knoxville, Tenn.
1975: Light Gallery, New York, N. Y.
1977: Rhode Island School of Design, Providence, R. I.
Selected group shows:
1970: Museum of Modern Art, New York, N. Y.
1973: Princeton Art Museum, Princeton, N. J.
         Hudson River Museum, Yonkers, N.Y.
1974: Photographers' Gallery, London, England
         Lowe Museum of Art, Miami, Fla.
1975: Addison Gallery of American Art, Andover, Mass.

Selected collections:
Museum of Modern Art, New York, N.Y.
International Museum of Photography at
George Eastman House, Rochester, N.Y.
Exchange National Bank of Chicago, Chicago, Ill.
Philadelphia Art Museum, Philadelphia, Pa.
Worcester Art Museum, Worcester, Mass.
University of New Mexico Art Museum, Albuquerque, N.Mex.
Kansas City Art Institute, Kansas City, Kans.
Princeton Art Museum, Princeton, N.J.
Museum of Fine Arts, St. Petersburg, Fla.

BECKY NEW

98.

When I was in graduate school in 1967, I started working with the idea of three-dimensional imagery in the form of Plexiglas boxes. For some time I had appreciated all sorts of objects dealing with spatial relationships and optical illusion. For example, I liked the 19th-century ambrotype, a negative on glass, which is backed with black to create the illusion of a positive. There were many other things, such as Victorian Easter eggs with peepholes into contained environments, and miniature dioramas with openings through which landscapes are revealed.

All of a sudden, it became evident that it was possible for me to make photographs three-dimensionally by suspending film positives in Plexiglas boxes. The kind of excitement produced by innovating an idea, working on a frontier, was very important to me at that time. I've since grown to feel that although originality of approach is important in one way, in another it isn't. Now I see the boxes simply as a way of making images.

I had a teacher who actually told me not to work on them because the artist Robert Rauschenberg had beat me to the idea. But Rauschenberg's work consists of large circular pieces that rotate. They had nothing to do with my work.

However, in ARTFORUM I had seen a box done by Carl Cheng, a California artist, and it really stole my thunder for a while. But by this time, the idea of working in three dimensions had become so well integrated into my thought process and vocabulary that I had to proceed.

The structure of the box itself fascinates me: all in plastic, held together with nylon screws. It conveys the idea of a futuristic hologram, in which the illusion is created of a real object suspended in space. At the same time, the box has the Victorian feeling of a photograph in a setting. It reminds me of the 19th-century daguerreotype done on silverplated copper, and held in a case.

When I am thinking about doing a box, the initial response, the first inspiration, is stimulated by the outside world. Perhaps I see something that I recognize as usable in a box. Perhaps I make a straight photograph in daylight, or use flash at night or indoors.

The second response is stimulated by the proof sheets, which have evolved into a very important part of my work, thanks to Jerry N. Uelsmann. It wasn't until I was teaching in Florida with Jerry that I even started to make them. Jerry said, "Oh, my God, you don't make proof sheets!" Until that time, I simply read my negatives, or thought I did. Proof sheets are the only way I have access to all of those 2¼ negatives (Figures 1 and 1A).

From the proof sheets, I try to figure out which images, and which combinations of images I want to work with. This is a very important point: when I'm working on a blend or making a straight photograph, I think in terms of combinations of elements, and therefore the boxes are

**Figure 1.**

**Figure 1A.**

related to the other ways in which I work. It would be unfair to separate them from the rest of my photography, and to see them as an isolated process. When I make a straight photograph, I may find elements of an environment, a light situation, a time, or a space that I want to combine in a single negative, a single exposure in the camera. The same thinking process takes place when I make a blend of more than one negative, bringing objects together with foreground and background, or sky and landscape, to form a new image.

Once I have selected possible pictures for a box, I make more contacts, but this time on graphic arts film (Figures 2

and 2A). Graphic arts film is a term used to describe a wide range of products made by many manufacturers, and readily available on the marketplace. Kodak happens to make the one I use, which is called Kodalith. There are many types of Kodalith, each one designed for specific applications in industry and commercial printing. I use the regular thin-based Kodalith Type 3.

**Figure 2.**

**Figure 2A.**

After cutting out the individual pictures printed on the Kodalith, I dump them onto the light table and start sorting them out. I may have a pile of foregrounds and a pile of backgrounds. I play with them until things click.

At this stage, two things happen in the creative process. One is that accidents take place. There is a real potential for random events, and I accept the accidental falling together of parts as a gift. But I do have some kinds of preconceptions, and the second step is to test whether those preconceptions coincide with the reality of the images when they are put on film and spaced apart.

I test my ideas by making miniature boxes out of the Kodalith contacts. I put 2'' square panels of Plexiglas together and hinge them on one side with tape. Then I slip the contacts between the layers of Plexiglas. From this "three-dimensional proof sheet," I get an idea of how the space will function. Here is a layer I am working on now, shown without background or foreground (Figure 3).

**Figure 3.**

To begin work on a finished box, I enlarge a negative onto Kodalith to the desired size, usually 4'' or 5'' square. An average exposure for an enlargement might be five seconds at f/16, but it varies (Figure 4).

My enlarger is a 4x5 MCRX Beseler. I use an EL-Nikkor lens, and a 150 watt bulb.

If I were printing the same negative on paper, I would use different filters or grades of paper to change contrast and achieve a full tonal range. But with Kodalith, I can change contrast only by working with developers. For the least possible contrast, I use a regular film developer like Kodak D-76. Each of the following Kodak products, in order, produces an increase in contrast: D-19, D-11, and D-8. Kodak DK-50 gives a continuous tone and medium contrast. The highest contrast is produced by Kodalith A&B.

**Figure 4.**

Most of the time, I use a paper developer made by Sprint called Quicksilver on the Kodalith. Quicksilver comes in liquid concentrate form, and is normally diluted 1:9 for paper. It gives a continuous tone image with medium contrast. If I want still less contrast, I take the 1:9 dilution as my stock, and dilute again: 1:1, 1:2, or 1:3. A ratio of 1:3 produces low contrast on Kodalith film.

Quicksilver is part of a system of products for the darkroom called Sprint Systems of Photography, Inc., manufactured by Paul Krot. These chemicals are available through some stores, but can be ordered directly from the manufacturer: 100 Dexter St., Pawtucket, RI 02860.

For me, Sprint Chemicals have three main advantages. First they are quickly mixed from a liquid concentrate, usually diluted 1:9, and are therefore extremely conve-

nient. I can run into the darkroom when I have a spare hour to print, and set up rapidly. Secondly, the developer, stop and fix have the same tray life. That is, they exhaust simultaneously, so I do not have to set up a new tray for one chemical in the middle of a session. Thirdly, they are designed to be used in close quarters because they do not give off noxious fumes.

With Quicksilver and Kodak developers, I control the contrast of the Kodalith film through manipulating the time, concentration and temperature. Overexposing and underdeveloping reduce contrast; underexposing and overdeveloping increase contrast. I also bring down contrast by increasing dilution while cutting developing time.

Working with transparent materials is very different from using reflected materials. I'm not sure about this in scientific terms, but the contrast range in a reflected image is about one-tenth that of the transparent image. Therefore the character of the emulsion is different in quality. Kodalith has taught me one of the basic concerns of photography is not so much the nature of black-and-white, but of transparency and opacity.

There is one thing we need to be careful about in referring to these materials. In regular black-and-white photography, the negative is usually on film, and the positive on paper. Therefore it is common to call anything on film a negative, and anything on paper a positive. This is confusing when the photographer is dealing with positives and negatives on both film and paper.

After developing the Kodalith, I use Sprint Stop Bath, called Block, 1:9, and the Sprint hypo, called Record Speed Fixer, 1:4, rather than 1:9 (Figure 5). I wash one minute.

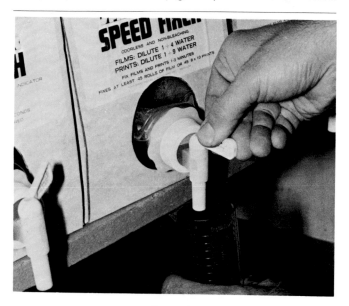

**Figure 5.**

Next, I use the Sprint hypo clearing agent, Archive, 1:9, for three minutes, and wash again for ten minutes. I finish with the Sprint wetting agent, End Run, 1:99, for one minute, which acts as an anti-static Photo-Flo.

I squeegee the graphic arts film and hang it up to dry on a line for about 30 minutes or so (Figure 6).

**Figure 6.**

The levels that go into a final box are usually the foreground, middle ground and background. Putting them together is like playing three-dimensional chess. I've got to know what the third level is going to look like when I put the first level on top. Therefore, in printing I try to balance the contrast and exposure of the layers by checking them against each other, so they don't cancel each other out when they are put together.

**Figure 7.**

After taking the three levels down from the line, I tape them on a piece of heavy cardboard, registering them on top of each other (Figure 7). The three sheets of film are in direct contact with each other; there is no need for any kind of protective interleaving.

Then I place a Plexiglas square on top of the Kodalith. The Plexi is pre-cut to the size of the image that will appear in the box. Using a series of light strokes rather than one heavy stroke, I cut around my template with a razor or matte knife (Figures 8 and 9).

| **Figure 8.** | **Figure 9.** |

This is a good point at which to discuss how the Plexiglas squares are cut. The sides of the boxes are made from Plexi ¼'' thick, and the inner panels are ⅛'' thick. Usually the inner panels are all either 4'' or 5'' square. When all the inner panels are assembled in a pack with the sheets of Kodalith, the thickness is 2'' to 3'', depending on the way I have decided to space the Plexiglas.

Let us assume that a particular box has inner panels 5'' square, spaced so that the box is 3'' deep. Then the two rectangular panels on the sides would each be 3''x5'' exactly. When I set the saw to cut lengths to be used for the top and bottom pieces, I allow for the dimension of the inside panel and the thickness of the Plexiglas used in the sides (¼'') minus the depth of the dado groove (⅛''). The panels on the top and bottom would each have an overage lengthwise to allow for the ¼'' thickness of the side panels. The top and bottom panels would each be 3''x5¼''.

I cut the panels to the proper dimensions with a Rockwell nine-inch tilting arbor table saw. I use a Sears veneer blade with a hollow-ground, fine-tooth blade. It's the same type of blade I would use in working with wood.

In fact, working with Plexiglas is rather similar to working with both wood and metal. I can use cabinetmaking tools, as with wood. At the same time, Plexi can be

machined, drilled and tapped like metal. But I do have to keep in mind that Plexiglas is heat sensitive, and if there is too much friction, it can melt. However, I leave the manufacturer's adhesive paper backing on the sheets while cutting, and there isn't too much of a problem. The paper backing protects against scratching of the Plexiglas.

I cut the panels out of large Plexiglas sheets that are usually about 3' or 4' long. Standard sizes vary with the manufacturer. As in woodworking, I figure out the most economical utilization of the sheet, and make my cuts

Figure 12.

Figure 10.

Figure 13.

Figure 11.

accordingly (Figures 10-13).

The next step is to cut grooves on the inside of the top and bottom panels. The inner panels slide into the grooves, which are made with a dado blade, used in cabinetmaking. The height of the blade controls the depth of the groove, and the number of thin blades put together controls the width. The right combination is usually about ⅛'' deep, with a width of ¼'', if I am sliding a double inner panel into a single groove.

In a given box, there may be two to four pieces of Kodalith film, and three to eight Plexiglas inner panels. There are many possible spacings of these film-and-Plexi sandwiches. For example, one possibility might be the following: panel, film, panel, film, panel, film, panel . . .

103.

all assembled in one solid unit. Another combination might be this: panel, film, panel, space; panel, film, panel, space; panel, film, panel. The inner construction of the boxes varies, depending on the spatial effect I am seeking.

After all the grooves are cut, I assemble the box with a couple of panels taped in place. I drill a hole in each corner of the top and bottom panels, into which a screw will be set (Figures 14 and 15). I use No. 4 nylon screws, ½'' long, with a No. 40 thread size.

**Figure 14.**        **Figure 15.**

When all eight holes are drilled, I number each side of the box so that when I put it back together the holes will match. This is very important. I have to take the box apart to countersink the holes and to put in threads.

The next step is to take the clean panels and, using a camel's hair brush and air, remove the dust. I then sandwich the film between the panels (Figure 16).

**Figure 16.**

At this point, I finish the edges of the side panels, either by sanding, which produces a matte finish, or by polishing with an electric buffer and a buffing compound. Usually the side panels are made of clear Plexiglas, but sometimes I use smoky gray. After the paper is removed, I clean every surface with an anti-static plastic cleaner.

Then I put everything together.

The object is now complete.

In this presentation, I have concentrated on the use of Kodalith and the actual construction of Plexiglas boxes (Figures 17 through 20). However, I would like to backtrack briefly to describe how I make the original negatives.

I use a 2¼ Hasselblad 500C Super Wide with a 38mm lens, and another 500C with an 80mm lens. My film is Plus-X rated at ASA 64.

My film developer is Kodak D-25 at 68 F for nine minutes. It is used in conjunction with a bath of one percent solution Kodalk at 68 F for three minutes. The D-25 and Kodalk Balanced Alkali function as a two-step developer. The combination gives a very long tonal range in a soft negative, which I prefer. The developer exhausts itself first in the highlight areas, but the shadow areas continue to develop, allowing greater detail in the shadow areas without increasing contrast.

I develop film two reels at a time in a steel tank. I agitate continuously the first 30 seconds, and then five seconds out of every minute. I use Sprint chemicals for stop bath, hypo, hypo eliminator, and wetting solution. Then I hang the negatives up to dry on a line.

The negatives are pretty consistent, and I proof them all at the same exposure. I can go back over a hundred sheets and give an accurate estimate on contrast and exposure. The negatives and proof sheets are keyed to each other; all are numbered and filed chronologically.

I cannot keep the proofs in a notebook because I am constantly shuffling them. I mentioned this to a class one day while discussing the value of accidents in my work.

They said, "Yeah, but your darkroom is so organized."

I replied that imagery created through accident is of no value unless I can find the negatives when I want to work with them. My method is a combination of things being organized and things being out of control.

I am considering exploring questions of scale and tonal quality, and I'm beginning to experiment with toners and developers to see what variations I can get. I intend to be involved with the boxes on a continuing basis, but I do not wish to work in one direction exclusively.

| FILM | ASA RATING | DEVELOPER | SOLUTION & TIME | AGITATION |
|---|---|---|---|---|
| Plus-X | 64 | 2 parts: D-25 and Kodalk Balanced Alkali | 9 minutes undiluted 68 F ——— 3 minutes 1% solution 68 F | Continuous for first 30 seconds, then 5 seconds in every minute ——— Continuous for first 15 seconds, then 5 seconds in every 30 seconds |

| ENLARGER | LENS | LIGHT SOURCE | USUAL APERTURE | USUAL EXPOSURE |
|---|---|---|---|---|
| 4 x 5 MCRX Beseler | EL-Nikkor 80mm f/5.6 | No. 150 | f/16 | 5 seconds |

| PAPER | DEVELOPER | SOLUTION & TIME | STOP BATH | FIXER |
|---|---|---|---|---|
| Kodalith Type 3 Graphic Arts Film | Sprint Quicksilver | 1:9; dilute again 1:1, 1:2, or 1:3 ——— 1½ minutes | 10 seconds Sprint Block Stop Bath 1:9 | 1 to 3 minutes Sprint Record Speed Fixer 1:4 |

| WASH | TONING | DRYING | FLATTENING | PRESENTATION |
|---|---|---|---|---|
| 1 minute wash ——— 3 minutes Sprint Archive 1:9 ——— 10 minutes final wash ——— 1 minute Sprint End Run 1:99 | Currently experimenting | Air dry | None | Sandwiched between Plexiglas panels to form a box |

**Figure 17.**

**Figure 18.**

**Figure 19.**

**Figure 20.**

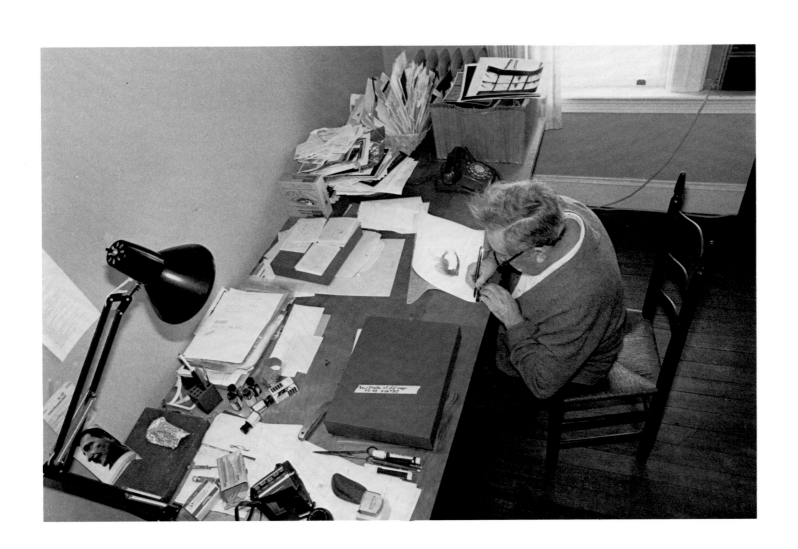

# AARON SISKIND

Aaron Siskind was born in New York City in 1903. After graduating from City College in 1926, he began a 23-year career of teaching English in New York City public schools. He joined the Photo League in 1932. During the 1930s he contributed to photojournalistic essays such as DEAD END: THE BOWERY, PORTRAIT OF A TENEMENT and THE HARLEM DOCUMENT. Also during the '30s he made studies of architecture, such as TABERNACLE CITY.

After 1944 his work took a more abstract turn, and he produced such series of studies as: MARTHA'S VINEYARD, TERRORS AND PLEASURES OF LEVITATION, FEET, CHICAGO, ROME, CORFU, etc.

In 1961 he became head of photography at the Institute of Design in Chicago. From 1971-76 he was adjunct professor at the Rhode Island School of Design.

Selected one-man shows:
1947: Egan Gallery, New York, N.Y.
1952: Portland Museum of Art, Portland, Ore.
1954: International Museum of Photography at
       George Eastman House, Rochester, N.Y.
1955: Art Institute of Chicago, Chicago, Ill.
1958: San Francisco State College, San Francisco, Calif.
1964: Art Institute of Chicago, Chicago, Ill.
1965: International Museum of Photography at
       George Eastman House, Rochester, N.Y.
1972: Light Gallery, New York, N.Y.
1974: Light Gallery, New York, N.Y.
1976: Light Gallery, New York, N.Y.
       Art Institute of Chicago, Chicago, Ill.

Selected collections:
Metropolitan Museum of Art, New York, N.Y.
Museum of Modern Art, New York, N.Y.
International Museum of Photography at
George Eastman House, Rochester, N.Y.
Art Institute of Chicago, Chicago, Ill.

The idea of photographic space as integral to the very concept of a picture became clear to me around 1944, when I was working in Gloucester, Mass. I became sold on the fact that this "space" is like an arena, a place where the action is, and I found out how powerful it could be. I took a picture of a glove, and it's all in there (Figures 9 and 10).

I had made photographs of other gloves. As you walk along the wharves in Gloucester you see among other things old fisherman's gloves lying on the waterfront. But something happened in this one. I took a 3¼ x 4¼ camera and aimed it straight down, lining up the edge of the glove with the line of a wharf plank. In effect, I took something lying down, something you normally see filling a certain visual space at a certain perspective, and stood it up, so that it faced you. I went from oblique to flat space. It's like a stage or arena, and everything takes place there. Nothing else exists. It's not abstraction, but it's taken out of its context, away from its original life. The only life the object possesses is expressed within the picture space.

During the previous summer on Martha's Vineyard, I had walked along the wharf and beach picking up familiar organic objects: bits of wood, a fish head, a fish bone in a certain shape. To make a picture, I just put the objects down in different places. When I returned to New York in the fall, I developed and printed the pictures. I found something astounding about those photographs: their uniformity. The uniformity had to do with my choice of, what should I call it, a "formal ground," usually broken up into rectangles upon which was placed an organic object, usually photographed straight down. The thing that struck me was the interplay between the formality and rigidity of the ground, and the emotional qualities one usually assigns to organic objects. These photographs became metaphors for the conflicts between intellect and emotion that were very much concerning me at the time; for example, complexities inherent in the relationship between man and society, government and people, and so on. It seemed to me that by working innocently, but very intensely, I had come up with an idea central to my own being.

This was very exciting! Before that, I had been photographing primarily in a very bland way, a documentary approach: you decide what you want to do and you do it. But here was something new, a situation in which I was making a picture without any conscious direction. By letting all the things that go into making a picture act on me, I was working intuitively. At the time, I did not think it all out quite this clearly, but I decided definitely that when I went to Gloucester the next year I would work without a program, without any pre-decisions.

I realized that this is a very tough way to work. It's very easy to get a job and a guy says, "Photograph this chair, and I want it in a certain way." But how do you work when

you don't know clearly what you're doing?

Every day I loaded enough film to take six pictures, which meant 12 sheets of film and a film pack as a backup. I used a 3¼ x 4¼ camera with Isopan or Plus-X. I don't know if I even had a light meter then. I was "brought up" without a meter in the 30s. I did what I had always done. I took two or three varied exposures of each object.

Making those six pictures was, in one sense, very simple. I went to a wharf, just stood around, and then took pictures. I couldn't seem to work for very long periods, but when I got through, I was awfully tired. I couldn't wait to get to a restaurant to sit down and have a sandwich.

The encouraging thing was that certain signals indicated I was working with great involvement. One was the exhaustion. Another had to do with my smoking all the time. I had a cigarette in my mouth even when I was under the black cloth, and once someone tapped me on the back and shouted, "Hey, Buddy, you're burning up!"

I was completely absorbed in the need to get the subject matter down on the film. The pictures themselves have a certain innocent and simple quality about them. And that was good, and I did it for a long time.

The photographs I did in 1944 attracted the painter Barney Newman, who was a friend of mine. He brought our mutual friend, Adolph Gottlieb, up to my place. Gottlieb was doing his pictographs, breaking up the space into rectangles and putting little organic shapes in them; heads, faces and hands. And here I was doing the same thing! Of course, I continued working, but my photographs went away from the pictographic concept; my images concerned the object in a controlled environment.

Technically, I was self-taught and not very precise, and this actually became the whole basis of my picture making. I find out what the picture is about when I print it in the darkroom, not when I take it. Since I do not previsualize the print, I make a negative which gives me certain options.

For me, the negative must be very "full," with lots of detail, and yet some contrast. I am very careful of the density, to insure detail in the shadow areas, should I decide to keep that detail.

Today I often go out shooting with a Rollei SL66 camera, making up to three exposures of each subject. I may take along Panatomic-X, Plus-X, and Tri-X. My choice of film is determined largely by how much contrast I want. For example, I can get more contrast and greater separation with Panatomic-X, which I rate at 25 ASA.

An important thing to remember is that photographers worked for years and years with only the tips of their noses to figure out the light reading. Although I always use my meter today, it is basically a departure point. My film exposure, whether "normal," "over," or "under," is determined by my sense of the print-to-be.

When I overexpose, it's because I want to flatten down the whole situation. So I overexpose the negative and underdevelop it, catching the point of most desirable density. Then, if I print the negative normally, and find that it is lifeless (perhaps a figure isn't strong enough, or the texture is dull) I have to try other alternatives in printing.

I develop my film primarily in Microdol-X, but also in Kodak D-76. When I return from a trip, I have perhaps 30 or 40 rolls, all to be developed in Microdol-X. First I arrange the negatives according to sunlight and shade values. Then I develop them all by inspection. I use D-76 "straight" when I want a stronger, more contrasty negative. Often I run four or five sheets of photo paper though a gallon of fresh D-76 to "work it down," because the freshly made chemical is very, very active. I'm a bit casual about replenishing D-76 because I can judge just how far the development has gone during inspection.

I don't really know how long I develop the negatives. I usually take the temperature of the chemicals and consult the instruction chart. If the chart advises, let's say, 7 minutes, I set my timer at only 4 or 5 minutes, because I agitate continuously. Around 4 minutes, I put on my green safelight to see how far the development has gone. Then I go further as needed. I would say my tendency is toward overdevelopment. I followed the same procedure when I was working with cut film and film packs.

One of the principal problems with 2¼ negatives is the danger of flare at the edges if you develop in a tank. Everybody has this type of problem, and there are endless discussions on how to agitate in every how-to book. All development is probably uneven to some degree. We aren't perfect, and even when we're very careful, we might get a little uneven development. If we print on a No. 2 or No. 3 paper, the uneven edges won't show up, but if we start with No. 4 or No. 5 paper, they will be noticeable.

I had the same difficulty with tanks when I used 5 x 7 film. Way back in 1949, I had a 5 x 7 Linhof with which I was traveling around the country while on sabbatical. I was off in Arizona photographing, and developed the film in a hard rubber tank. Negative after negative came out terribly flared at the edges, and I thought my camera was on the blink. I took it to a camera store, and the technician examined it. He said the camera was fine, but the film still came out flared. So I tried an experiment, thinking perhaps the problem was in the development. I made two negatives of each image, and developed one in a tank and the other in a tray. Sure enough, the one in the tank had flare, and the one in the tray was absolutely perfect. Similarly, many years before, I had experienced difficulty with 3¼ negatives. I just lived with it, but a friend suggested sending samples to Rochester to get an opinion. At the time, the opinion was that my holders were faulty.

The upshot of these years of experimentation is that I tray develop my negatives "spaghetti style." I just place the negative strip in the tray and roll it up and unroll it, roll it up and unroll it. The result is absolutely even development.

I've had very good luck with absence of fogging during inspection of the negatives. The only film with which I do pick up fog on occasion is Tri-X. But with Panatomic-X I can hold the negatives right up to the green safelight without getting into difficulty. Years ago photographers used to immerse the negatives in a dye to protect them from the safelight. But I tried inspecting without dye, and it worked.

I used to store the negatives in glassine envelopes, but I began to have bad experiences with the glue discoloring the film. Now I store them in typewriting paper (Figure 1). I number and code the negatives on the paper, for example: date, GL-1-1944 (for Gloucester) or GL-1H-1944 (Figure 2). I also keep an extensive filing system (Figures 3 and 4) and a record indicating size, number of prints, etc.

**Figure 3.**

**Figure 1.**

**Figure 2.**

**Figure 4.**

After developing the film, I make proofs (Figure 5). If the photographs concern, say, configurations of plants or people, I examine the contacts with a magnifying glass and consider cropping (Figure 6 and 14). If I am doing studies involving the texture of a wall or a tree, I enlarge the negatives to see all the options (Figures 11 and 12). Not only do I enlarge them to 8 x 10, but I often make two and sometimes three proofs to explore possibilities (Figure 7). If, for example, I want a deeper shadow area in the print, I put marks on the back of the sheet to indicate what I have done, and what I would like to do. I see what the negative is capable of producing.

**Figure 5.**

**Figure 6.**

**Figure 7.**

When I print, I use Kodak Polycontrast paper, or, when I want higher contrast, Agfa Brovira in the various grades. I prefer an unferrotyped glossy surface.

It is the negative that gives you the concept of the final print. If, for example, you do a journalistic picture and give it to a lab to print, the lab technician knows how that negative is to be printed in terms of journalistic standards. Now, someone who knows me and is working with me, would be aware that I am concerned that the print not "fall off" in certain areas, and this knowledge of me and my negatives would affect the printmaking decisions.

There is no great skill in making a print: you have an idea how to print a particular image in terms of the way you have already printed pictures in the past. The problem becomes to look at every picture. You have to make small decisions on changes to achieve your intention. The ultimate meaning comes out in the final print.

Often I print a picture and simply accept it as it is: I have made a decision. This is the way it should be for now. A few years from now I may print it differently. It's always a matter of discovery, but fundamentally it has to do with an evolving philosophy; everything changes.

For example, my printing of the glove picture (see Figures 9 and 10) has changed through the years. One problem in this picture has to do with the nature of the "ground." How dark to print it, how light? I remember that Edward Steichen wanted to use the photograph in an early show at the Museum of Modern Art. He asked me, "Can you print it a little more brilliantly?"

I said, "No."

He said, "You should make the glove come out."

I said, "But I want the glove to be in there."

Later on, I changed the printing of the picture a little. I was able to keep the glove in there, but also to make it a little more brilliant, which is what Steichen desired, and what I later came to desire.

My printing style in the early years also had to do with the fact that I was very incompetent, and my darkroom was very crude, with an enlarger that gave me several problems. I didn't study with anyone; I didn't work in anyone else's darkroom to see how he did it. What I knew I just picked up from people.

In those years I made my prints small. But later I found another idea emerging: the idea of "presence" as related to scale. In the beginning, my idea of presence had to do with the power of the glove itself, that flat thing that I had made stand up in the picture space. But when I considered that word, presence, I began to think of something a little more dramatic. I went to galleries and saw paintings that required a little viewing distance. I looked at them and thought, the size of the things in the picture frame emphasizes their nature as objects. The glove is also an object, and I wanted to make it bigger.

But there was something else about that glove when I compared it to paintings. If someone had painted the glove, it would have been schmaltzy. It wouldn't have worked. But photography is related to what we call "reality" in a very special way. There will always be a conflict, a tension, between what I'm saying and what the picture is saying. There is something self-defeating going on. I want to make a "pure" picture, and yet I cannot. I'll never be able to make it. But I insist that the object be there; I can almost lick it. And the only way I can inject my idea is to take the object out of context, and work with the tonalities a little. It's the object, and yet it isn't the object. It's what some call the surrealistic nature of photography.

It's very important to stress that when you are working from a philosophic base, no matter what subject matter you use over the years, there will be a continuity in, or relationship between your pictures. From this point of view, there is a relationship, for example, between the glove picture and the photographs of the divers I made in 1954.

I was walking along the lake in Chicago, and I saw these guys jumping off a diving board. It was a beautiful Sunday, and I was just walking along with my Rolleiflex. I sat down and started taking pictures of them without knowing exactly what I was doing, only that I was taking pictures of divers. The results didn't particularly interest me until I looked at one that struck me. This guy was a diver, but he wasn't a diver. He was levitating as if in a dream state, and then I knew what I was after. Once I had the idea, I knew about the tonalities, and the pictures evolved.

Now, the right light conditions are either the result of luck or careful planning. Here I happened to be working on a lake with an hour or two to shoot before the sun climbed high enough to light up the figures, giving them too much detail. I wanted the sun behind the divers, or on the edge, to achieve contrast and a minimum of detail (Figure 13).

We as photographers have basically so little to work with in a picture. There's a given space, which we repeat over and over again. It presents a problem because I may want to change the space without changing the dimensions of the space (Figure 8). I had this problem with the meaning of the divers in relation to the kind of space surrounding them. The picture had to be square because I was working with the Rolleiflex. No two square pictures are square in the same way. Some are heavy at the bottom, and so they extend beyond the square. Some become horizontal depending on how you weight the space with blacks, whites and intermediate tones.

**Figure 8.**

In the case of the divers, I wanted no clouds, only white (or gray) in the space enveloping the figures: seemingly endless space. And so I print the divers on high contrast paper, Agfa Brovira No. 5 or even No. 6, if necessary.

I used Tri-X film at 1/500th, to freeze the figures. Sometimes there is a little motion blur, but that's all right.

When I was photographing trees on Corfu in 1970, my aim was to allow the shapes and figures to exist in themselves. My feeling was that the shadows cast by the sun would interfere with the modulation of the forms. So, based on a little experience, I determined that I was going to work in shade. I could just see those shapes. That's why I

like to work on the shady side of the street, too. I don't like the sun breaking in. I like the idea of the light seeming to emanate from the picture rather than the light hitting it from the outside. I wanted the forms of the trees to live in their own "dream," rather than in the "dream" of the sun.

I related much of the imagery to my contact with Greek sculpture, and the Greek fables about creatures that live in trees. The trees assumed many forms: bursting, womb-like shapes and bellies, or flames moving at the center. I was looking for the Bogey Man, I was looking for wounds, and I saw them (Figures 15 and 16). Working in the olive groves of Corfu was like being alone in the studio: it was so quiet, with all the imposing structures to consider.

The technical problem of working in the shade was the danger of a gray quality. I had to overexpose slightly for detail in the depths and overdevelop to get increased contrast, thus brightening up the image and achieving strongly modeled shapes along with the detail. It was particularly difficult on Corfu, for when I was working on the shady side of a large tree trunk I was photographing against the light, and this tended to flatten the tonalities. On Corfu, I used both a viewcamera and a Rollei SL66.

I took a light reading right off the shadows. When I couldn't do that, I took a reading off my hand and doubled or tripled it. By and large, the exposure was not that "over." It was roughly equivalent to a gray card reading. Then I developed the negatives a little longer. But the negative must not be too dense, or the tonalities disintegrate.

A photographer should not confuse the concept of working from a philosophic base with the idea of previsualization. I think that previsualization constricts the imagination, reduces the artistic possibilities, and does all sorts of anti-picture-making things. The photographer who says he previsualizes does so in order to maintain that he makes the pictures, not the camera. At one time photographers had to say that to give photography status. Edward Weston used to say he saw the picture when he looked in the ground glass, and how all of the parts would relate to one another tonally. He said, "When I look in the ground glass, I see the finished picture." To me that notion is just horrible, because then the picture making ends when the photographer clicks the shutter.

I believe that no photographer can say he does not believe in accident. A real photographer is so involved in the excitement of the main event, so to speak, that he cannot see everything that goes into his picture. There are endless things that can and do happen, both in the camera and in the darkroom, and you have to let these accidents take place. If you are photographing a new event, then you've got to let it work its way into becoming a picture.

| FILM | ASA RATING | DEVELOPER | SOLUTION & TIME | AGITATION |
|---|---|---|---|---|
| Panatomic-X<br>———<br>Plus-X<br>———<br>Tri-X | 25<br>———<br>100<br>———<br>200-400 | Microdol-X<br>———<br>D-76 | Undiluted<br>———<br>by inspection | Continuous,<br>spaghetti style<br>in tray |

| ENLARGER | LENS | LIGHT SOURCE | USUAL APERTURE | USUAL EXPOSURE |
|---|---|---|---|---|
| Omega D2V | Schneider Componon<br>150mm<br>f/5.6 | 211, 212<br>or<br>213 | f/11, 16, 22 | 8 to 30 seconds |

| PAPER | DEVELOPER | SOLUTION & TIME | STOP BATH | FIXER |
|---|---|---|---|---|
| Polycontrast<br>Rapid<br>———<br>Agfa Brovira<br>Nos. 4, 5 and 6 | Dektol | 1:1½<br>———<br>2 to 3 minutes | Glacial acetic<br>acid<br>———<br>1 oz. per gal.<br>———<br>30 seconds | Sodium Thiosulfate<br>(1 qt. crystals to<br>4 qts. water) and<br>1½ oz. Kodak Liquid<br>Hardener<br>———<br>2 baths<br>———<br>2½ minutes |

| WASH | TONING | DRYING | FLATTENING | PRESENTATION |
|---|---|---|---|---|
| 1 hour in<br>East Street<br>Gallery Washer | Selenium<br>———<br>1½ oz. selenium to<br>1 gal. Kodak Hypo<br>Clearing Agent<br>solution<br>———<br>2 minutes | Fiberglas<br>screens | Drymount press,<br>sandwiched between<br>museum boards | Unmounted<br>———<br>100% pure rag<br>overmattes |

Figure 9: GLOUCESTER, MASSACHUSETTS, 1944 (Version 1)

**Figure 10: GLOUCESTER, MASSACHUSETTS, 1944 (Version 2)**

**Figure 11: ROME 2, 1973 (Version 1)**

122.

**Figure 12: ROME 2, 1973 (Version 2)**

Figure 13: TERRORS AND PLEASURES OF LEVITATION, 1954

**Figure 14: VITERBO, 1970**

Figure 15: CORFU, 1973

**Figure 16: CORFU, 1973**

NEAL SLAVIN

Neal Slavin was born in 1941 in Brooklyn, New York. In 1961, he received a scholarship to study Renaissance painting and sculpture at Oxford University. He was also the recipient of a Fulbright fellowship to photograph in Portugal in 1968; a National Endowment for the Arts grant in 1972; a New York State CAPS award in 1977; and an NEA grant to document Mexican-Americans in 1977.

Slavin's work has appeared in numerous publications, including LIFE, THE NEW YORK TIMES, NEW YORK, POPULAR PHOTOGRAPHY, ARTFORUM, etc. Two books of his photographs have been published: PORTUGAL (Lustrum Press, New York, 1971) and WHEN TWO OR MORE ARE GATHERED TOGETHER (Farrar, Straus & Giroux, New York, 1976).

Slavin has a commercial studio in New York City. He has taught photography at Manhattanville College, Cooper Union, Queens College, and the School of Visual Arts in New York.

Selected one-man shows:
1967: Underground Gallery, New York, N.Y.
1968: National Museum of Ancient Art, Lisbon, Portugal
1971: Royal Ontario Museum, Toronto, Ontario, Canada
       Underground Gallery, New York, N.Y.
1972: Halsted 831 Gallery, Birmingham, Mich.
       Focus Gallery, San Francisco, Calif.
1976: Light Gallery, New York, N.Y.
       Center for Creative Photography, University of Arizona, Tucson, Ariz.
       University of Maryland, Baltimore, Md.
       Silver Image Gallery, Tacoma, Wash.
       Photokina, Cologne, Germany
       Wadsworth Atheneum, Hartford, Conn.
       Oakland Museum, Oakland, Calif.

Selected collections:
Museum of Modern Art, New York, N.Y.
Metropolitan Museum of Art, New York, N.Y.
International Museum of Photography at
George Eastman House, Rochester, N.Y.
Center for Creative Photography, University of Arizona, Tucson, Ariz.
University of California, Los Angeles, Calif.
Oakland Museum, Oakland, Calif.
Chase Manhattan Bank, New York, N.Y.
Stedelijk Museum, Amsterdam, The Netherlands
Exchange National Bank, Chicago, Ill.

The Polaroid photograph is one of the most significant innovations in the history of the medium. Even the exploration of color has not stimulated such a fundamental change in the very concept of what a picture is and does. With instant imagery, the photographer no longer possesses a magic space in time between the taking of the picture and the making of the print in which to live out his fantasies. Polaroid gives us the picture quicker than we would really like, and this characteristic alters our relationship to reality and to our subjects.

My photography is very subject-oriented. I like to create an atmosphere of rapport and trust. Through the immediate feedback of Polaroid, the subject can see what is happening, and become involved in a way that's not possible otherwise. In my current work, Polaroid is also extremely important as a means of relating many of my ideas about theatre, fantasy and personal narrative.

As an artist, I am very responsive and open to my own thought process. After I have been working with a particular idea for a long time, I ask myself: What do I do next? After I pursue one idea thoroughly, how do I branch out into other ideas? How do I attempt to relate my new ideas to my previous work without hardening into a single style? The artist is still the same person fundamentally, but his work must be free to change if he is to grow.

I've heard photographers say, "It took me five years to make this picture." We all know what that means: there are elements in the photographer's life and physical environment that are not quite right when he first attempts to make the picture. And so he keeps on trying. Then one day all of the elements come together.

For several years I had been making photographs of people in group situations. I studied them for a long time, trying to understand what was happening in the pictures. In part, the images had to do with the splitting up and rearranging of subject matter in a structured setting.

I decided I would like to find some kind of "stage setting" with which to control fragmented subject matter. This form would serve as the housing for other ideas. Eventually it would fall away and another form would come along.

As the first step in the process, I decided to work with a single subject to make a series of photographs of fragments of the body. I worked with a model, making many Polaroids of the foot, the hand, the head, etc. (Figure 1). I placed these pictures on a table and sorted through them, trying to get ideas about how to proceed (Figure 2).

The next step was to use some kind of "grid" as a framework for the model's body. There were various props and parts of stage settings in my studio, including a bay window once used in a play. The window was a large rectangle, approximately 58" wide x 70" long. It consisted of 24 window panes without glass.

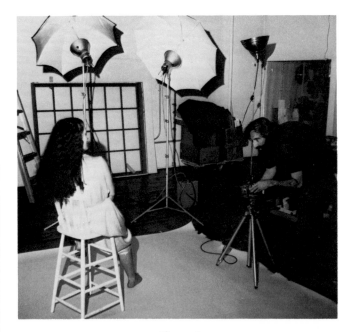

**Figure 1.**

**Figure 2.**

I covered the grid with squares made of black bristol board. I knew that by putting black in front of the camera, I could create an underexposure. Then, when I wanted to expose an area, it would be a simple matter of removing a square and photographing the model (Figure 3).

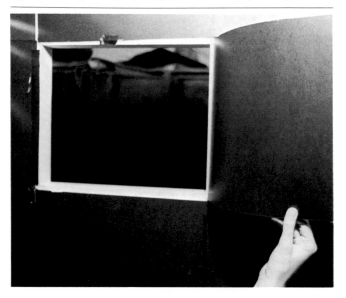

**Figure 3.**

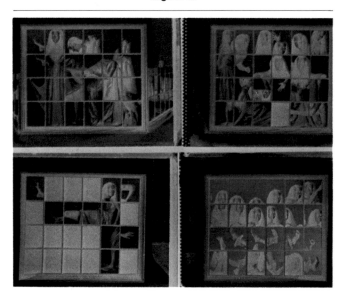

**Figure 4.**

Instead of exposing an entire sheet of 4 x 5 Polaroid at the same time, I exposed the film in sections (Figure 4). I have made up to 11 exposures on a single sheet of Type 55 Polaroid, keeping track of the sequence and location by making a drawing of a grid and numbering in the parts (Figures 5 and 6). The areas numbered "1" represent the set of squares exposed by the first click of the shutter; "2"

represents the second set, and so on. The contrast of the Polaroid print holds up well through the second and third sets. By the fourth and fifth sets a slight "flattening out" effect begins to take place as density builds on the negative. Eventually one reaches a "point of no return" at which the negative becomes completely overexposed.

Head in front of window—

Figure 5.

Figure 6.

The Polaroid negative responds well to slight overexposure and this characteristic works to my advantage. When a photographer gives normal exposure to a Polaroid positive, the negative portion is underexposed. This means that to get a good negative from which to make prints in the darkroom, the photographer must overexpose.

I use two Calumet strobe heads at full power to light the grid from behind. If I put the lights in front of the grid, the picture is washed out within two or three exposures. It is important that the model stand close to the grid, but not so close that part of her is erased by the next exposure (Figure 7). At first I left the two lights in stationary positions, but I am now experimenting with moving them around to see what effects I can get.

Figure 7.

I use a very small aperture, like f/22 or f/32. Between exposures I place a film box over the lens to guard against stray light (Figure 8). I don't recock the shutter or use a lens cap because I am afraid of jarring the camera, which would destroy the registration of the image.

**Figure 8.**

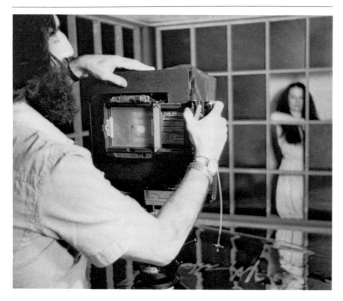

**Figure 9.**

It may take 20 minutes to expose all the positions of the grid, or it may require a week or more to plan out all the elements of the photograph.

After I have made my exposures (Figure 9), I flip the control arm of the film holder to "P" (process). As I pull out the Polaroid film packet (Figure 10), the steel processing rollers come together, crush the developer pod, and spread the developer evenly between the positive and negative. If I pull out the packet too quickly, I may get a mottled effect due to air bubbles; if I hesitate while pulling, I may get streaks. The processing time begins the moment the film packet is pulled out of the holder and ends as soon as the positive and negative are separated (Figure 11).

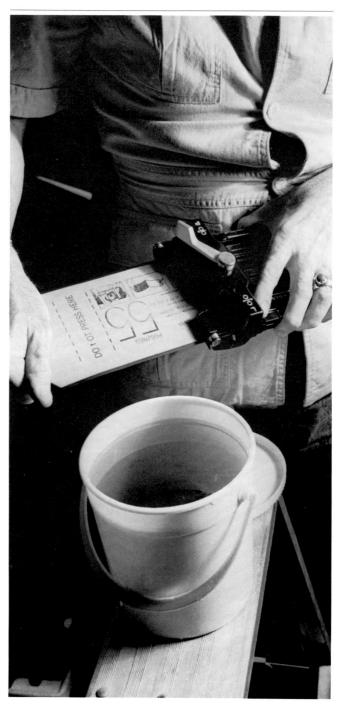

**Figure 10.**

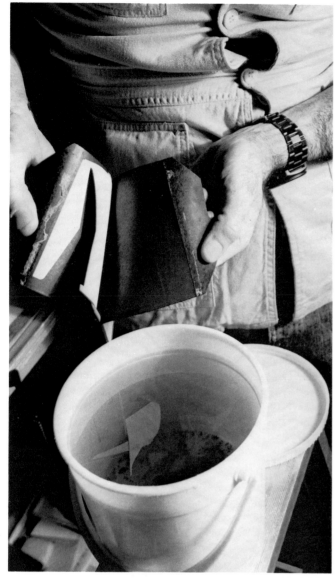

**Figure 11.**

**Figure 12.**

**Figure 13.**

The normal development time for Polaroid is 20 to 25 seconds. I go to a minimum of 30 seconds, and sometimes up to 60 seconds, to build contrast.

After separation from the positive, the negative goes into an 18% sodium sulfite bath (Figure 12). The solution consists of 16 oz. anhydrous sodium sulfite mixed with 70 oz. warm water. Sodium sulfite can be purchased readily. The solution should be cooled to 70 F before use.

The negative should go into the solution within 3 minutes after being removed from the film packet. The purpose of the bath is to remove excess developer and dyes before they harden (Figure 13). I leave the negative in the sodium sulfite bath for 2 or 3 minutes. It can be left in the solution up to 72 hours.

Polaroid makes a 6½" tall portable bucket, a "negative clearing tank," to hold the sodium sulfite solution and negatives. The bucket has slots to keep the negatives from getting scratched, but I remove the slot holder and simply slip the negatives into the solution. An advantage of the bucket is that it can be carried out on location, and the negatives can be stored safely for a long time.

The tab is removed from the negative, and then the negative is washed in running water for 5 minutes. It is not really necessary to fix it, but I prefer to do so to help prevent scratches. I use ordinary Kodak fixer with hardener for 5 to 10 minutes. Finally, I wash the negative again in running water for 5 minutes, and hang it up to dry. If desired, the negative can be treated with hypo clearing agent and Photo-Flo. The point is, the Polaroid negative can be treated like any other negative.

One of the aspects I most like about the Polaroid negative is its physical thinness and crispness. It seems to me that a thin negative offers less resistance to light and produces a crisper print, although I realize that this thought may not be provable in scientific terms.

My printing paper is Agfa Brovira, often in grades No. 4 and 5. I started to use Brovira because it makes a strong, gutsy print, and I like that feeling. I want a rich, deep black, which means I have to go back to the print and really burn down the highlights (Figure 14). I'd rather work with this set of problems than the problems of softness.

The processing of my prints is standard. I develop them in Dektol 2:1 for 2 minutes. Then I transfer them to 28% acetic acid solution for 20 seconds. I use Kodak fixer in two baths, at 5 minutes per bath. I tray-wash for 2 hours after immersing them in Perma Wash solution for 3 minutes.

I am now doing this work in 8 x 10 color Polaroid, rather than Type 55 P/N materials. I am thinking in terms of developing a "language of colors" in my photography: green as fantasy/desire, yellow as fear, red as actuality, etc. I also keep notebooks in which I make sketches and write thoughts on my evolving ideas. The written portions have become a "personal narrative" that I regard as an important part of the work itself.

My grid has developed into a three-sided stage set (Figure 15). Each side is about the same size as my first grid; each is painted a different color. The set rests on a mylar-covered platform and the ceiling is made of studio flats.

I come from a painting background in which the artist experiences great control over what goes into his work. The element of control allows the artist to get closer to what he is doing, to be more responsive to the work itself as it is in progress. To me, this approach is the most exciting concept I've ever worked with. It allows me a form to bring together all of the ideas with which I'm involved.

| FILM | ASA RATING | DEVELOPER | SOLUTION & TIME | AGITATION |
| --- | --- | --- | --- | --- |
| Polaroid Type 55 P/N | 50 | *NA | 30 to 60 seconds | NA |

| ENLARGER | LENS | LIGHT SOURCE | USUAL APERTURE | USUAL EXPOSURE |
| --- | --- | --- | --- | --- |
| Omega D2V | Schneider Componon 135mm f/4.5 | 211 | f/8 or f/11 | 40 seconds |

| PAPER | DEVELOPER | SOLUTION & TIME | STOP BATH | FIXER |
| --- | --- | --- | --- | --- |
| Agfa Brovira | Dektol | 2:1 ——— 2 minutes | 28% acetic acid solution ——— 20 seconds | Kodak 2 baths ——— 5 minutes each |

| WASH | TONING | DRYING | FLATTENING | PRESENTATION |
| --- | --- | --- | --- | --- |
| Perma Wash solution 3 oz. per gal. 3 minutes ——— tray wash 2 hours | None | Fiberglas screens | Drymount press, sandwiched between 2 pieces of 100% acid-free pure rag museum board | Undrymounted, overmatted with 100% acid-free pure rag museum board |

*Not Applicable

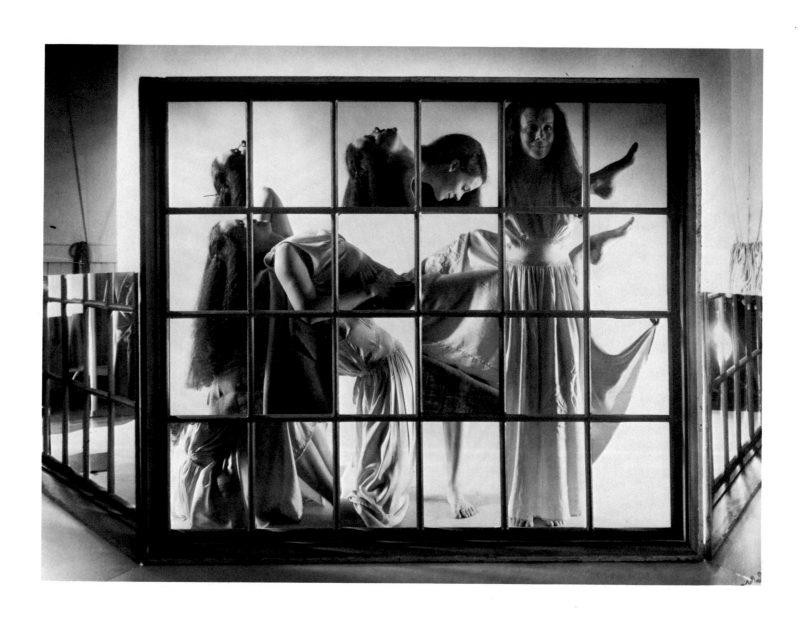

**Figure 14.**

138.

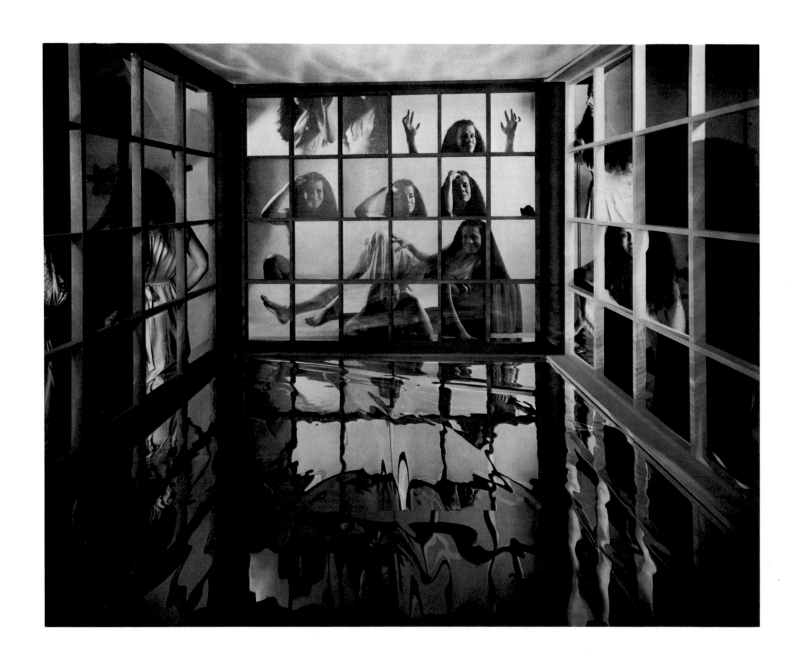

**Figure 15.**

# COLE WESTON

Cole Weston was born in 1919 in Los Angeles, California. He graduated in Theater Arts from the Cornish School in Seattle in 1940. During World War II, he worked at Lockheed Aircraft Corporation and then as a U.S. Navy photographer. After the war, he photographed for LIFE.

At the request of his father, he moved to Carmel in 1946. He assisted Edward Weston in his photographic work until the elder Weston died in 1958. Cole's career is multi-faceted: photographer, theatrical director, politician, trout farmer, executor of the Edward Weston Estate, sailor of the South Seas, filmmaker and lecturer.

Selected one-man shows:
1973: Focus Gallery, San Francisco, Calif.
1974: Afterimage Gallery, Dallas, Tex.
1975: Halsted 831 Gallery, Birmingham, Mich.
1976: Witkin Gallery, New York, N.Y.
1977: Halsted 831 Gallery, Birmingham, Mich.
1978: Leiserowitz Gallery, Des Moines, Ia.

Selected collections:
Philadelphia Museum of Art, Philadelphia, Pa.
Fogg Art Museum, Harvard University, Cambridge, Mass.

## Edward Weston's ABC Pyro Formula

### Solution A

water — 32 oz.
sodium bisulfite — ¼ oz. plus 35 grains
(or a total of 144 grains)
pyro — 2 oz.
potassium bromide — 16 grains

### Solution B

water — 32 oz.
sodium sulfite — 3½ oz.

### Solution C

water — 32 oz.
sodium carbonate, monohydrated — 2½ oz.

### 70 F

Stock Solution C — 1 oz.
Stock Solution B — 1 oz.
Stock Solution A — 3 oz.
added to 30 oz. water

When I got out of the Navy in 1946, I started photographing for LIFE Magazine in Southern California. My Dad, Edward Weston, wrote me that he needed an assistant because he was getting frail from Parkinson's disease. Would I come? So I sold my house and moved to Carmel to help him. I stayed with him until he died on New Year's Day, 1958. After his death, I continued printing his negatives, following the provisions set down in his will.

Edward Weston's approach was to previsualize the photograph on the ground glass, before the shutter was clicked. The work in the darkroom was a follow-up to the creative part, not the creative part itself. My responsibility to Dad's negatives is to duplicate the way he printed them, not to make "interpretations."

Most of Dad's negatives were made with Agfa Isopan, which he loved. It was discontinued more than 20 years ago, and I don't know what today's equivalent would be. It had an ASA of about 25, but he cut it down to ASA 12 when he developed with Pyro.

He used ABC Pyro, a low energy developer, in a very dilute solution. Pyro is also known as Pyrogallol. I have a letter from Dad with his Pyro formula for negatives, and his Amidol formula for prints (Figure 1). He sent it to me when I was assigned to the Navy photo lab in Oklahoma in 1943. I was having a hard time with the assignment. I thought that if my father would send me his formulas, it would help me.

For ABC Pyro, he kept three bottles of stock solution.

The usual proportions for developing negatives consisted of 3 oz. Solution C, 3 oz. Solution B, and 3 oz. Solution A, added to a tray of 30 oz. water.

However, Dad cut Solution C and Solution B down to 1 oz. each. By diluting the formula and developing for 15 to 20 minutes at 70 F, he extended the tonal scale of his negatives. Dad preferred to use distilled water, but I have had good results with ordinary tap water.

Dad tray-developed his negatives to avoid unevenness. First he presoaked them in a tray of water for 2 to 3 minutes. Then he put them in a second tray, which contained 1 oz. Solution C and 1 oz. Solution B in 30 oz. water. He kept the 3 oz. of Solution A to the side, adding it at the last minute, before transferring the negatives to the second tray; pyro is very unstable and therefore oxidizes quickly. This is why ABC Pyro is not widely used today. He agitated continuously, and developed by inspection with a standard green safelight.

He put as many as eight or ten negatives into the tray at the same time if they were of rocks, or other subjects where the chance of unevenness was slight. For clouds, he developed only three or four negatives at a time.

Dad stored his negatives in glassine sleeves, where they remain to this day. He put an extra sheet of glassine inside

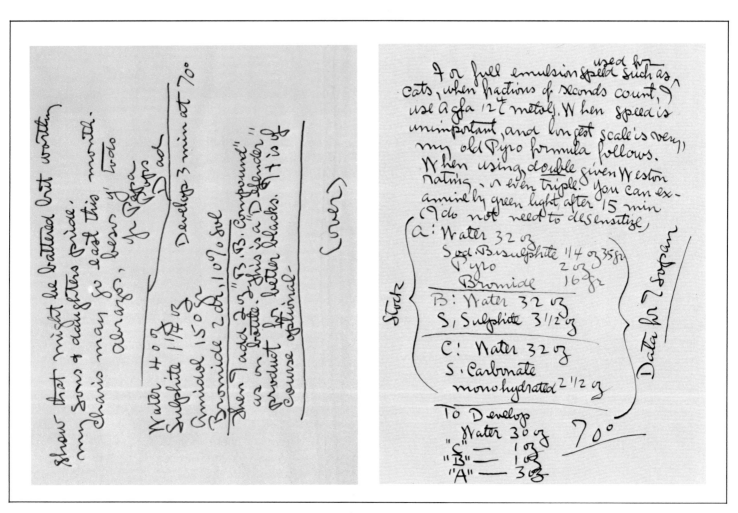

**Figure 1.**

144.

the sleeve to protect the negative from the glue line.

The negatives are coded in detail on each sleeve (Figure 2). The code might say "H-1, 100, X-15." That means Haloid paper, grade No. 1, 100 watt bulb, 15-second exposure. Then he gave burning and dodging instructions. Contrary to what many people believe, at least 50% of his negatives have to be dodged or burned in. This is a shock to many "Westonians" who think he just put the negative in the frame and made a contact print.

**Figure 2.**

For many years, Dad kept the negatives in his studio. Now they are stored in a fire-proof vault built in 1954. The vault contains about 3,000 8 x 10 negatives, at least 1,000 4 x 5s, and perhaps less than 100 2¼s. The 4 x 5s were largely his "bread and butter" photographs of customers who came to his portrait studio. We do not have an original print from each negative. In fact, there are boxes of negatives I have never looked through.

I have only two or three of Dad's old glass plates. He kept these few because they were of family members. During the 1920s, he had decided to get rid of his glass plates. He put us kids to work removing the emulsion with lye. Whenever a window broke in his studio in Tropico (now Glendale), California, he replaced it with one of the cleaned plates. We have no idea how many glass plates he simply threw away.

To prevent deterioration of the negatives in the vault, we keep the temperature at about 70 F and the humidity at 45%. Interestingly, the earlier negatives are in perfect shape. It is only the later negatives that show some deterioration at the edges, which seem to be getting more dense. We also have a problem with regeneration of the anti-halation backing, which results in purple discoloration.

To get rid of the discoloration, I give the negatives a sodium sulfite treatment:

---

water — 32 oz.
sodium sulfite — 14 grams
Soak negative in the solution for
3 minutes at 68 to 70 F, and wash in running
water for 15 minutes.

---

The treatment cleans up the entire negative. I've used it on perhaps 100 negatives.

The Weston negatives have been printed on a number of papers over the years. Early in his career, Dad used platinum paper. As he matured as an artist, he grew to feel platinum was too "soft" for his work, and he began printing on silver papers. The early silver papers were also relatively "soft" compared to most of the ones today. Among those that Dad used were Velox, Apex, Convira, Defender Velour Black and Haloid. Dad loved Haloid, which was manufactured by a company that later became Xerox. The paper had a wonderful warm tonality. Dad used to say it had a three-dimensional quality.

The papers I have used to print his negatives include Contactone, Convira and Agfa Brovira. A few years ago I started using Ilford Ilfobrom in grades No. 0, 1 and 2. Ilfobrom is the paper that has come closest to Haloid.

When I work in the darkroom, I place the paper and negative into a standard 8 x 10 wooden contact printing frame. Until two years ago, I used the same one Dad had. When the springs on the back of the original broke, I "retired" it, to be saved with other memorabilia, like his old mounting press. However, I still use Dad's dodging wires and his camel's hair brush for negatives.

On the contact printing frame I use now, I have marked "top" on both sides, so I can tell if I have turned it the right way under the safelight (Figure 3).

**Figure 3.**

I clean the glass on the frame with toilet tissue, just as Dad did (Figure 4). Dad used rolls, but thanks to modern technology, I have "progressed" to eight-inch squares. My flat-sheet toilet tissue dispenser is marvelous (Figure 5). I confess I didn't buy it; I "acquired" it. The squares also make perfect weighing tissue on my darkroom scale.

The printing bulb is about three feet above the frame, attached to a tube that can be moved up and down (Figure 6). I use ordinary daylight frosted bulbs that can be purchased at any hardware store. I want a "cold" blue light.

Depending on the density of the negative, I use a 7½, 15, 25, or 60 watt bulb (Figure 7). As a diffusing aid, white tissue from the dimestore is wrapped around each bulb and attached with a string.

**Figure 4.**

**Figure 6.**

**Figure 5.**

**Figure 7.**

The 7½ to 60 watt bulbs work well for fast bromide papers like Agfa Brovira and Ilford Ilfobrom. Dad used the slower chloride papers, which require high-intensity light, 100 to 500 watts. I still have some of his old bulbs, which are much larger than the ones I use today (Figure 8). The disadvantage of high-intensity bulbs is that they affect the eyes over a period of time. Dad used to wear a tennis visor to protect his eyes during a printing session.

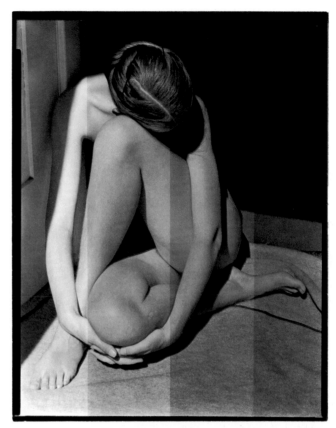

Figure 9: NUDE, 1936 Test strips

On the negative sleeve, Dad left instructions to hold back the shadow on the arm with a "small-small" wire. He used "small-small," "small," "medium" and "large" wires. The code also tells me to burn in the right side of the print a little, because it is too bright. So I burn in 6 seconds on the right side, 3 on the lower left corner, and 4 on the foot (Figure 22). Usually I burn in with my hands, but for difficult areas I cut a hole in a sheet of mounting stock.

Figure 8.

To print NUDE, 1936 (Neg. No. 227N) (Figure 10), I use a 15 watt bulb because the negative is not dense. Dad left instructions on the negative sleeve to use Haloid No. 1. The closest paper today would be Ilfobrom No. 0. I make a test strip at exposures of 5, 10, 15 and 20 seconds (Figure 9). Although I have printed this negative many times, second in number only to the famous PEPPER, 1930 (Neg. No. 30P), I still make a test strip before deciding on the final exposure. This is because I find that photographic paper of the same grade varies tremendously in speed from batch to batch. For this particular print, I decide on 12 seconds (Figure 21).

Figure 10.

With TOADSTOOL, 1931 (Neg. No. 6FU), I use a 25 watt bulb because it is a much denser negative. Again, I use Ilfobrom No. 0 to make tests at 5, 10, 15 and 20 seconds (Figure 11). I see that 5 is not enough and 10 is too much, so I do a straight print at 7 seconds. I usually make a straight print at the overall exposure, before beginning to burn and dodge, so I can get a better idea of what Dad was after (Figure 23).

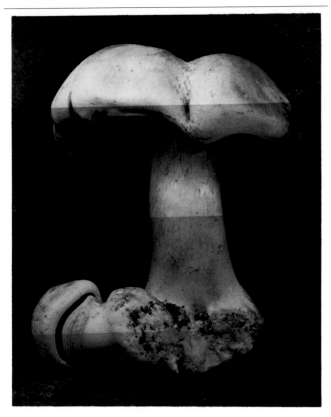

**Figure 11: TOADSTOOL, 1931 Test strips**

After studying the straight print and looking at the instructions on the sleeve, I see that Dad wanted to bring out the detail in the shadow of the toadstool. I hold back the left and right sides of the print with the large wire, dodging back and forth the whole time. The base of the toadstool is too light, so I burn in 7 seconds, while holding back on the left side with the large wire (Figure 24).

On EGGPLANT, 1929 (Neg. No. 16V), I use a 40 watt bulb because it is an extremely dense negative. Again, I make a test strip on Ilfobrom No. 0 at 5, 10, 15 and 20 seconds (Figure12). An exposure of 15 seconds appears to be best (Figure25). I burn in 7 seconds on the left side and 8 on the right, with 4 seconds additional on the base of the vegetable (Figure26). I feel that my first print is a little overexposed on the right side, and so I would probably cut down the right side to 6 seconds on the next print. I like this version, but it is a little too black, and I would prefer to bring out just

a little bit more detail.

**Figure 12: EGGPLANT, 1929 Test strips**

I think that having a long enough exposure is important. Too many photographers want to get the exposure over with in a hurry. I find that I can't do any dodging or burning in unless I have at least 15 seconds to work with. Even with a straight, unmanipulated print, I never go under 7 seconds because there is sometimes a fluctuation in electrical current even though I use a voltage regulator.

I still develop all of Dad's and my own black-and-white prints in the Amidol formula, although I have converted it to the metric system and use a larger volume to make more prints during a session. Dad added "BB Compound," a product made by the old Defender Corporation, which no longer exists. The benzotriazole in BB Compound acted as a restrainer. To my formula, I have added a 10% solution of citric acid. The function of the citric acid is to keep the developer "clean" and to make it last longer.

Edward Weston's Amidol Formula
3 minutes at 70 F
water — 40 oz.
sodium sulfite — 1¼ oz.
amidol — 150 grains
10% solution potassium bromide — 2 drams
optional: "BB Compound" — 2 oz.

Cole Weston's Amidol Formula
3 minutes at 70 F
water — 60 oz.
sodium sulfite — 54 grams
amidol — 16 grams
10% solution potassium bromide — 12cc
10% solution citric acid — 12cc

My development time is 3 minutes, the same as Dad's, although sometimes I go up to 3½ minutes depending on what the print looks like as I inspect it in the developer tray. I use a standard darkroom timer as I am developing, but Dad had a little 3-minute glass egg timer with sand inside. He also kept a rusty old alarm clock with a loud tick, which served as a metronome for counting seconds during exposure of a print. He put his tray of Amidol on a light box with a red electric bulb to keep the temperature up to 68-70 F when the darkroom was cold.

I develop ten prints at a time in a gallon of Amidol. I set my timer at 4 minutes, and start putting prints into the developer face-down at 5-second intervals, each print underneath the preceding one. The last print in has "No. 10" written on the back. When the top print has been in 3 minutes, I pull it out, and draw out the others one by one.

By the time I pull the last one out, the first one has been sitting in the short stop a full minute. Each print is in the short stop for 1 to 2 minutes.

I use two hypo baths, a procedure recommended for archival processing. Once the prints start going into the hypo, I set my timer at 8 minutes. I agitate constantly the first 2 or 3 minutes in the hypo. Then I just let the prints sit, and take them out one by one, repeating the same process in the second hypo. Each print is in the first hypo for 4 minutes, and the second for 4 minutes. During Dad's lifetime, before studies had been conducted on archival processing, he put his prints into only one hypo bath.

For the two fixer baths I use sodium bisulfite and hypo. It is the old and simple formula:

mix at 80 F
(cool to 68-70 F for use)
water — 1 gal.
sodium bisulfite — 86 grams
hypo — 2 lbs.

I mix the fixer in two one-gallon baths. Today's first bath will be thrown out, and today's second bath will be tomorrow's first bath. This way the second bath is always kept completely fresh.

In the past, I have used Kodak Hypo Clearing Agent with selenium toner for archival processing. But now I am noticing a color change with selenium, and I don't know why. For this reason, I will probably stop using any toner.

After the prints come out of the hypo baths, they sit in a holding bath of water. I continue feeding prints into the holding bath until there are about 40. I remove the prints and give a final wash of 1 hour in the East Street Gallery Washer, before placing them on Fiberglas screens (Figure 13). Dad used a tray with a Kodak siphon for washing.

**Figure 13.**

I wash the prints in cold water because I don't have hot running water in my darkroom. When I need warm or hot water to mix solutions, I put a metal pitcher on a hot plate (Figure 14). The pitcher is marked on the inside at the one-gallon level, so it's easy to fill up to the mark even in the dark. I make my tea on the same hot plate.

**Figure 14.**

I often compare the prints that I make with our set of "Project Prints," which were made by my brother Brett under Dad's supervision. During 1954, Dad and Brett entered into a privately sponsored project to make eight prints of each of 1,000 negatives. In six months' time, they got up to eight prints each of more than 800 negatives before

stopping. We still have many of the prints, but many more have been sold over the years. Often we have several left of a particular negative, but we have only one master set and even it is not complete.

Before drymounting the prints, I "break" them by pulling them face-up, over-and-down across the edge of a table (Figure 15). This removes the curl without cracking the emulsion. I don't flatten with a drymount press. It's easier to "break" the print if I don't use hardener in the hypo.

**Figure 15.**

Next I tack mounting tissue onto the print, in the upper left corner and lower right corner, because I am left-handed (Figure 16). Then I trim the tacked print on a cutter. I have to be very careful. It is easy to trim at the wrong point.

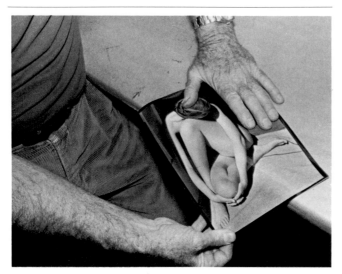

**Figure 16.**

After I have my prints trimmed and stacked, I pick up my horizontal and vertical mounting masks, or templates (Figure 17). By now they are very beaten and old. I have to make sure the mask is superimposed in precisely the right position over the mounting board, which is 100% acid-free pure rag museum board (Figure 18). The print is then positioned face up inside the cut-out in the mask.

**Figure 17.**

**Figure 18.**

I tack the print onto the mount board, first in the upper left-hand corner of the tissue, and then in the lower right-hand corner (Figure 19).

**Figure 19.**

I turn on my drymount press a good half-hour before I am ready to use it, and sometimes longer if it is humid. The only time I have trouble with the drymount tissue not adhering properly is when I don't turn on the press soon enough. I use a temperature of about 205 to 210 F for both Dad's and my black-and-white, as well as my color.

The tacked print is placed between two sheets of pure-rag paper in the drymount press, to prevent pinholes or pits due to dust or imperfections on the platen. I keep the platen meticulously clean.

When I take a mounted print out of the press, I "break" it again very slightly, gently bending the ends (Figure 20).

**Figure 20.**

Every now and then I set aside a mounted print, with drymounting details written on the back. For example, one I did in July, 1976, says, "Mount test, new Seal, 210 F." I was transferring to a new Seal press at the time, and I saved this sample for future reference.

In accordance with the provisions in Dad's will, I stamp the back of the drymounted print, "Negative by Edward Weston, print by Cole Weston," with my signature. During Dad's lifetime, he sometimes used his full signature, and sometimes only his initials. I have seen very early platinum prints with "E. W.," as well as others made during the 1920s with "Edward Henry Weston." When a later print bears the signature "Edward Weston," chances are good that the print was also made by Dad himself, rather than by one of his sons. On the other hand, if a later print is initialed, it is possible my brother Brett or I printed it. Brett and I are the only two people besides Dad who have printed the negatives.

I have a letter Dad wrote to a man who had ordered a print through the mail. Dad made the print, initialed it "E.W." and sent it off. The man requested a full signature. Dad wrote back, furious, to ask him what he was doing, buying a photograph or the Weston signature?

If I had to make a guess at how many prints Dad himself made in his lifetime, I would probably say 6,000 to 10,000. It's always of interest to young photographers to know that Dad did not begin to make a living from the sale of his own work until after he received his Guggenheim in 1938, when he was 51 years old. He lived very frugally even after he became well known. The most money he ever made in a single year was $5,000.

There was a period in the 1930s when Dad was persuaded that it would be a good idea to make numbered editions of his work, "1/30," "2/30," etc. But he soon gave it up. He felt that the only purpose of numbering prints was to drive up the market value for collectors, and this was not in keeping with his "democratic" ideas about photography. Even in the last several years of his life he sold his prints for only $35 each, because he wanted people who appreciated photography to be able to own one.

Most people don't know that Dad was very interested in the future of color photography. In 1947 Kodak sent him some color film with the request that he experiment with it. We still have 50 transparencies, some of which have been made into dye transfers. Had he lived, he would almost certainly have continued to work with color.

My own photography consists primarily of color work. I supervise the printing of the negatives by a color lab. Often I have the 8 x 10 transparencies enlarged up to a 16 x 20 print and mounted on 22 x 24 museum board.

About 20% of my work is in black-and-white. I use the same procedures for processing the negatives and prints I

have outlined for Dad's work. The films I use are Super Double-X, Plus-X, and Tri-X. They are all good films, and they work well in ABC Pyro.

I have just purchased an 8 x 10 Salzman enlarger with a Berkey color head. I am building a new darkroom around this monster and plan to do all of my own dye-transfer and Cibachrome prints in the future.

In 1947, Willard Van Dyke (standing next to cameraman) filmed Edward Weston in his darkroom for the movie THE PHOTOGRAPHER. (Photograph by Cole Weston.)

| FILM | ASA RATING | DEVELOPER | SOLUTION & TIME | AGITATION |
|---|---|---|---|---|
| Plus-X ———— Super-XX ———— Tri-X | ½ manufacturer's recommended ASA rating | ABC Pyro | By inspection ———— 15 to 25 minutes | Develop in tray ———— Constant agitation |

| ENLARGER | LENS | LIGHT SOURCE | USUAL APERTURE | USUAL EXPOSURE |
|---|---|---|---|---|
| NA (8 x 10 contact printing frame) | NA | 7½, 15, 25, 40 or 60 watt bulb | NA | 7 to 15 seconds |

| PAPER | DEVELOPER | SOLUTION & TIME | STOP BATH | FIXER |
|---|---|---|---|---|
| Ilford Ilfobrom grades No. 0, 1, 2 ———— Double weight glossy | Amidol | Undiluted ———— 3 minutes | 28% acetic acid solution ———— 1½ to 2 minutes | Hypo and sodium bisulfite ———— 2 baths ———— 4 minutes each |

| WASH | TONING | DRYING | FLATTENING | PRESENTATION |
|---|---|---|---|---|
| East Street Gallery Washer ———— 1 hour | None | Fiberglas screens | Hand-break | Drymounted on 100% pure rag acid-free museum board |

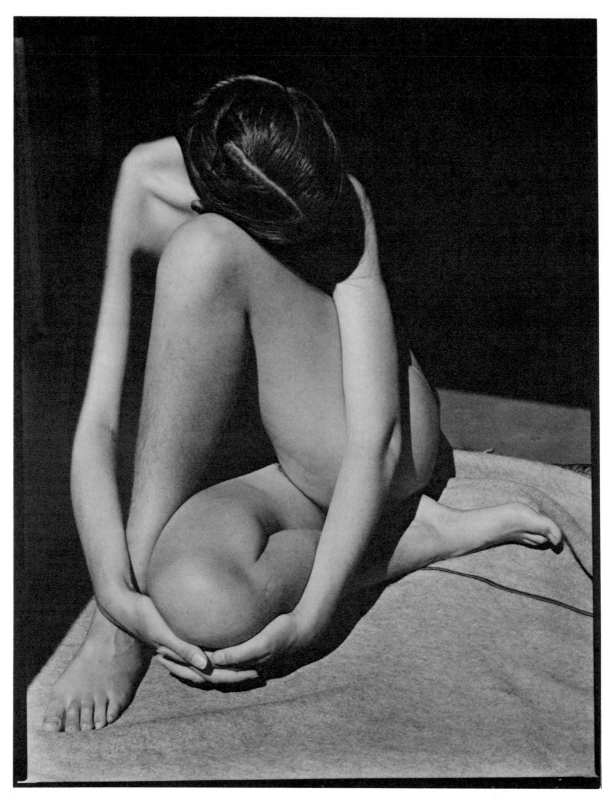

**Figure 21: NUDE, 1936 Straight print**

154.

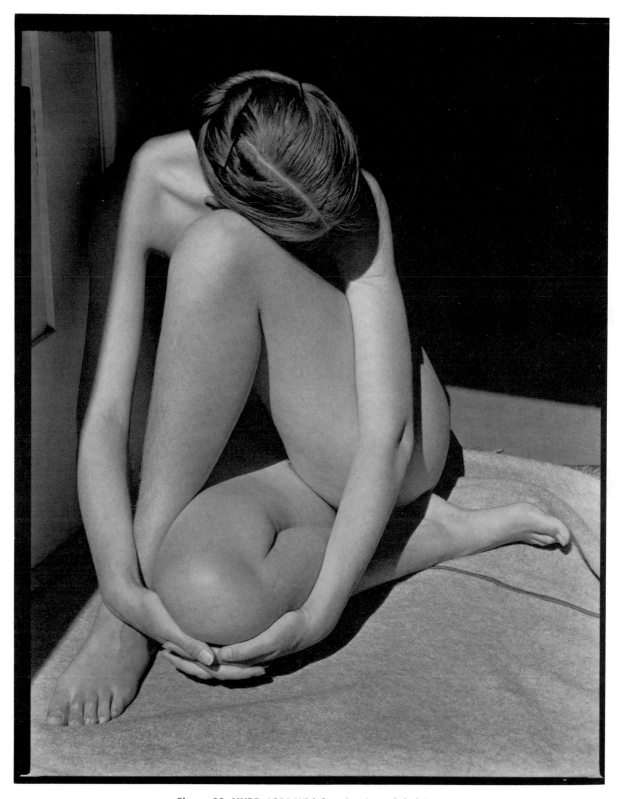

**Figure 22: NUDE, 1936 With burning in and dodging**

**Figure 23: TOADSTOOL, 1931 Straight print**

**Figure 24: TOADSTOOL, 1931 With burning in and dodging**

**Figure 25: EGGPLANT, 1929 Straight print**

**Figure 26: EGGPLANT, 1929 With burning in**